IMAGES
of America

BELLEVUE
POST WORLD WAR II YEARS

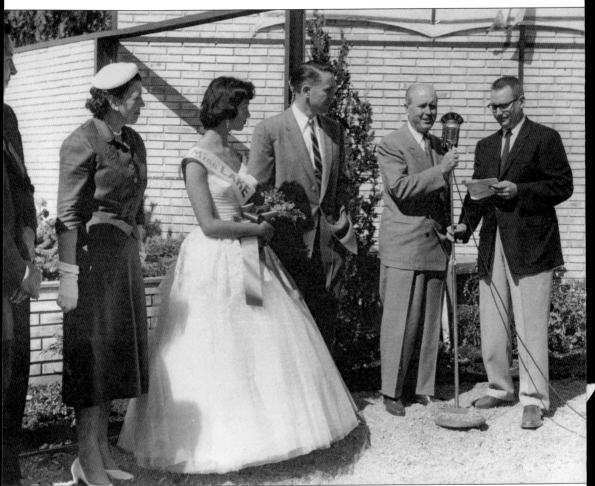

MISS LAKE HILLS. The Lake Hills development got underway in the mid-1950s, and although it did not annex to Bellevue until the late 1960s, it symbolized the rapid creation of brand new communities across the Eastside in the years following World War II. Here, Miss Lake Hills is about to be interviewed on *Country KAYO*. (From the collection of the Eastside Heritage Center.)

ON THE COVER: MIDLAKES, 1962. Midlakes had grown up around the train tracks just behind the photographer, and the confluence of Northeast Eighth Street and the Bellevue-Redmond Road formed the busy east entrance to Bellevue. By 1962, thousands of new homes had been built to the east, and this bottleneck stood between those residents and the amenities of downtown Bellevue. (From the collection of the Eastside Heritage Center.)

IMAGES
of America

BELLEVUE
POST WORLD WAR II YEARS

Eastside Heritage Center

ARCADIA
PUBLISHING

Published by Arcadia Publishing
Charleston, South Carolina

Printed in the United States of America

Library of Congress Control Number: 2013951696

For all general information, please contact Arcadia Publishing:
Telephone 843-853-2070
Fax 843-853-0044
E-mail sales@arcadiapublishing.com
For customer service and orders:
Toll-Free 1-888-313-2665

Visit us on the Internet at www.arcadiapublishing.com

This book is dedicated to the spirit of Bellevue, through which thousands of women, men, and children carved a very real place out of farms and forests. Bellevue's success in the 2000s is a testament to the vision and hard work of the individuals and families who set the stage in the postwar years.

CONTENTS

ACKNOWLEDGMENTS

This book was a team effort on the part of the staff and volunteers at the Eastside Heritage Center (EHC). Executive director Heather Trescases got the project underway and kept us all in line. Collections manager Sarah Frederick tracked down photographs and coordinated a wonderful team of volunteers who found images and the historical details that make these books such fun. Nancy Sheets and Julianna Hawes spent countless volunteer hours at EHC headquarters, Mary Ellen Piro provided historical details, and Lynn Sherk provided editorial support.

Thanks to Midori Okazaki and Phil Stairs at the Puget Sound Regional Branch of the Washington State Archives for their patience and assistance.

A special thanks goes to my partner in crime, Diana Schafer Ford, whose ideas, energy, and enthusiasm made this project happen.

Finally, thanks to the board of the Eastside Heritage Center and its many friends in the community who provide the support needed to collect and manage the archives from which these books start.

Throughout the book, unless otherwise noted, images are from the Eastside Heritage Center collection.

—Michael Luis, project coordinator

INTRODUCTION

Over the Floating Bridge to Bellevue . . . and to a New Way of Living

A brochure from the Bellevue Chamber of Commerce in the 1950s invited residents of Seattle to venture across Lake Washington and leave the old city behind. And, as this book shows, tens of thousands of families took them up on the idea.

The Seattle area had grown up during World War II, with people arriving from throughout the West to work in its airplane factories, shipyards, foundries, and mills. But ever since the onset of the Great Depression, homebuilding had been slow in the region, and all these newcomers, along with the GIs returning from the war, needed places to live. The central parts of Seattle were, by this time, largely built out, and home builders looked for new areas to settle. All that empty space across the bridge to the east looked very tempting.

And it should have. The area that is now Bellevue was the last part of the Eastside to gain any sort of urban form. The Eastside had first settled from the north, through Kirkland and Redmond, and from the south, through Renton and Newcastle. Bellevue, the least accessible part of the Eastside, attracted mostly farmers. Stores and service businesses clustered around Main Street, but most of the commercial activity of the Eastside took place in Kirkland.

Then came the bridge that changed everything. In 1940, the revolutionary floating bridge opened across Mercer Island and into the Eastside, just south of Bellevue. Part of US Route 10 over Snoqualmie Pass, the new bridge shortened trips from Seattle to Central Washington and beyond. But the new corridor had a more immediate impact on the far side of Lake Washington.

Before that could happen, however, World War II got in the way. The Seattle area was a major center for wartime machinery—aircraft from Boeing, tanks from Pacific Car & Foundry, ships from yards in Houghton and along the Duwamish—and the population of war workers increased dramatically. But the war effort left little room for home building, and gasoline rationing made suburban commutes difficult, so the new bridge languished for a while.

The end of World War II did not bring resurgent prosperity to the Seattle area as it did many other parts of the country. The region's economy was tied mostly to capital goods production and could not make a quick shift from war production to consumer goods the way the rest of the country did. So, while suburbs started blossoming around cities in the Midwest and East, the east side of Lake Washington took off more slowly.

But by the late 1940s and early 1950s, Boeing had recovered from its postwar slump, building a new generation of military and commercial jet aircraft. Now, with GIs graduating from college and starting families, and with Boeing beginning to rehire, the region's tight housing supply really began to pinch, and builders looked beyond the Seattle city limits. That bridge now made the Eastside look very attractive. Before Interstate 5 was built, traveling north and south to the employment centers of Seattle was a real chore, with the only options being the old state highways like Aurora Avenue and Empire Way and their endless stops and starts. In contrast, the Mercer Island bridge offered a fast, nonstop ride directly into downtown Seattle. The Eastside land rush was on.

The largest-scale developments grew up near the Route 10 corridor: Lake Hills, Newport Hills, and Eastgate. These developments featured modest ranch houses and split levels on quarter-acre lots with the newly prevalent winding streets and cul-de-sacs. Affordability was the name of the game, so designs were standardized, and basements, eliminated. Modernism had made complex

shapes and decorative touches unfashionable, further saving costs. These new homes seem small and dull by today's standards, but for a generation raised on the deprivation of the Depression and the war, they were a blessing.

Each development had its own neighborhood shopping center, but these only offered the basics of a supermarket, drugstore, and a handful of other businesses. The real action got underway in downtown Bellevue. A few businesses had started to spring up around the intersection of 104th Avenue (now Bellevue Way) and Northeast Eighth Street prior to World War II, and by the mid-1940s the first stores of the Bellevue Square shopping center were built. In the 1950s, the area between Northeast Eighth Street and Main Street filled in with supermarkets, car dealers, banks, service stations, real estate offices, and all the other businesses that a growing community relies on.

Something else had to grow too, and fast: schools. The baby boom was in full swing. All those subdivisions bulged with children, and as they reached school age, the old buildings could not accommodate them. Prior to the war, six separate school districts had served the greater Bellevue area: Bellevue, Highland, Phantom Lake, Medina, Houghton, and Factoria. Each district had its own elementary school, and in the 1920s, several of them had pooled their resources to create the Union S High School. But this was not a model for education that would work in a growing community, so in 1942, all six districts merged into the Overlake School District, later named Bellevue District 405.

And once all those families started moving in, bringing with them both children and property taxes, the district went on its own building boom. Between 1952 and 1972, it opened 25 new elementary school buildings, six new middle schools, and three new high schools. These schools were built quickly and mostly followed a "California" style of open corridors. This style proved inexpensive, but not lasting, and nearly all of these schools have been replaced.

As Bellevue began to grow in the 1950s, it was missing one critical thing: local governance. The entire area between Houghton, on the north, and Renton, on the south, remained unincorporated King County. That meant that most decisions concerning all-important matters like planning and zoning were being made by three county commissioners in Seattle. It also meant that the area had no voice of its own in larger regional questions of freeways, public transit, and sewers.

So, in 1953, voters in the area immediately surrounding downtown Bellevue opted for incorporation. At first, the new city was not very big, with a population of just under 6,000. The bulk of the new subdivisions getting underway were well outside the boundaries of the new city but were served by the existing Bellevue School District and by existing fire, water, and sewer districts. These areas would all annex to Bellevue in the 1960s and 1970s.

Once city government was in place, it wasted no time in getting improvements underway in its core. An aggressive street program turned the two-lane country roads of downtown Bellevue into four- and five-lane roads. In the auto-centric view of the time, the city decided to create "superblocks" in much of the downtown area. This made large developments possible, but it also limited circulation. The basic street grid that defines downtown Bellevue was largely in place within a decade, with many of the big new four-lane streets, complete with sidewalks, passing through unbuilt land: city planners knew big things were coming.

As can be seen in the photographs in this book, development of Bellevue's commercial areas was not exactly neat and tidy. Rapid growth gave rise to many quick-and-dirty structures that were needed to provide services to the new residents. An auto-oriented culture placed an emphasis on access and parking, creating streetscapes that, by the standards of both then and today, lacked much aesthetic appeal. The newcomers were simply too busy creating businesses and community amenities to pay much attention to the bigger picture. Like suburbs everywhere in this era, Bellevue was overtaken by a sort of splendid chaos.

But behind that chaos was a civic leadership that knew what it would take for Bellevue and the Eastside to thrive. There would need to be a set of community institutions that would make it increasingly unnecessary for residents to travel to Seattle. Kemper Freeman Sr. kept expanding Bellevue Square into a large, regional shopping center, with branches of department stores

found in downtown Seattle. Bellevue gradually acquired a full set of car dealers, banks, clothing stores, and other services that would make a trip across the lake more of a special occasion than a necessity.

In the late 1950s, the community got behind a drive to create an institution that any growing community needs: a hospital. Overlake Hospital opened in 1960, and while modest, it did offer enough healthcare services to make residents feel more secure and less subject to the whims of cross-lake traffic.

By 1960, through both internal growth and annexation, Bellevue had grown to 12,800 residents, and would grow to over 61,000 by 1970. This burst of growth was fueled by three related developments. First, Interstate 405 opened a larger north-south route through the Eastside, linking Bellevue to a wider range of employment centers, and bringing Bellevue's first big employers like the Coca-Cola and Safeway facilities.

Second, Boeing began its massive expansion starting in the late 1950s with the success of the 707 and the launch of three airplane programs—the 727, 737, and 747—plus the ill-fated SST. As Boeing's employment grew past the 100,000 mark in the late 1960s, Bellevue started to resemble a company town. With both Renton and Paine Field easily accessible along the newly completed Interstate 405, much of the company's engineering and corporate workforce settled on the Eastside. And with all those Boeing employees, demand for retail and other services was not far behind.

The third event that turned on the growth afterburners was completion of the State Route 520 bridge between Seattle and Medina. In its first phase, the freeway route only got as far as Interstate 405, but the impact was immediate. The more lightly developed neighborhoods on the north end of Bellevue began to fill in, and commuters to Seattle got a second route to town—a route that did not feature the dangerous mid-span "bulge" of the Mercer Island bridge.

The 1960s also saw the full build-out of Bellevue's school system. The fourth high school, Interlake, was completed in 1967, and its final junior high school, Ringdall, opened in 1970. Meanwhile, the Issaquah School District expanded its reach up the shores of Lake Sammamish and up the sides of Cougar Mountain, so that by the time Bellevue annexed those areas, they were firmly in the Issaquah camp, giving Bellevue two school districts.

As the larger city grew, the commercial area of Bellevue gradually evolved from the chaotic jumble of small businesses into a more coherent center. The first large office building was the headquarters of Puget Sound Power & Light. When Seattle completed the municipal takeover of electric power in 1951, Puget Power needed to move out of the city, and it chose to locate in downtown Bellevue. Its modernist building at the corner of 106th Avenue and Northeast Fourth Street, opened in 1956, was both a jarring exception to the low-rise landscape and a sign of larger things to come.

In the 1960s, a handful of "skyscrapers" sprouted on 108th Avenue, their prominence accentuated by their position on a ridge above downtown. Apartment complexes, a sure sign of urbanism, began to appear on the fringes of downtown. Bellevue's position as a viable regional office market was cemented in 1970 by the construction of the Business Center, now the Paccar Building, on one of the last remaining pieces of pasture in the area.

By 1970, at the close of the period covered by this book, Bellevue had grown into the fourth-largest city in the state and was poised for steady growth. The Boeing Bust would slow things down briefly, but by the mid-1970s, SR-520 was extended, big-box stores had sprung up in Overlake, and new office buildings and hotels were underway along Interstate 405. Bellevue was still largely a bedroom community, but for residents not inclined to head into Seattle for shopping and other services, the Eastside offered nearly all they needed.

Looking back on this era, we can spot clues that might explain how Bellevue dodged the fate of so many of the postwar "inner-ring" suburbs. In metropolitan areas across the country, the newer suburbs that grew up in the 1980s and 1990s—with their larger homes, sparkling schools, and more-sophisticated malls—left the original postwar suburbs languishing behind. This has not happened to Bellevue, which remains a premier residential and business address.

Geography has certainly played a role in Bellevue's recent success, as has strategic public and private investment. But that investment would not have happened if Bellevue had not retained a very strong sense of place. The young leaders of Bellevue in the 1950s had a vision for a community that would stand on its own and not be just a wide spot on a freeway that headed farther out of town. Being named an "All America City" by *Look Magazine* in 1956 may seem hokey and boosterish in retrospect, but the name of the award says volumes about how Bellevue viewed itself: a real city.

So, as you enjoy the photographs in this book, look past the scruffy exteriors and the often thrown-together feel of the place. The women and men and children who created Bellevue out of a small town deserve credit for laying a strong foundation for what has become one of America's greatest suburban successes.

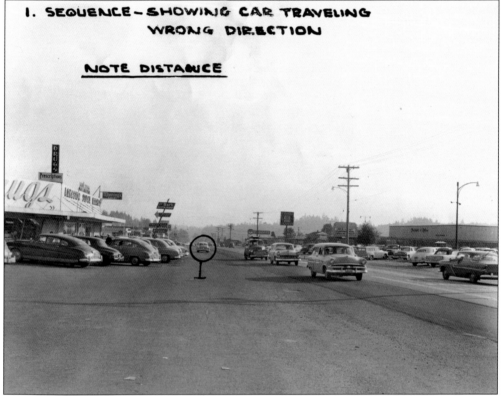

BELLEVUE IN 1955. This 1955 photograph, complete with comments by the city engineering department, shows 104th Avenue at the entrance to Bellevue Square. The city, incorporated for only two years at this point, was about to feel the impacts of a huge rush of population moving into the new subdivisions to the east and south. Such thoughts might not have worried residents on their way to the Bel-Vue Theater, where the marquee shows a double bill of *Love Is a Many Splendored Thing*, starring William Holden and Jennifer Jones, and *Female on the Beach*, starring Joan Crawford and Jeff Chandler. (Courtesy of the Washington State Archives.)

One

POSTWAR BELLEVUE

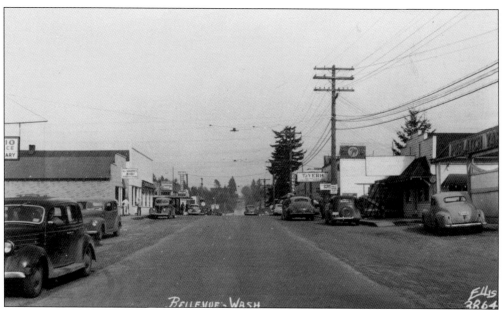

MAIN STREET IN THE 1940S. Bellevue began along Main Street, with a cluster of businesses taking root uphill from the ferry dock in Meydenbauer Bay. The sparse population of the area and the ability of residents to take a road to Kirkland or a ferry to Seattle meant that Bellevue would have a limited market for goods and services. Although new retail businesses had begun to emerge to the north, Bellevue at this time was still defined by its Main Street.

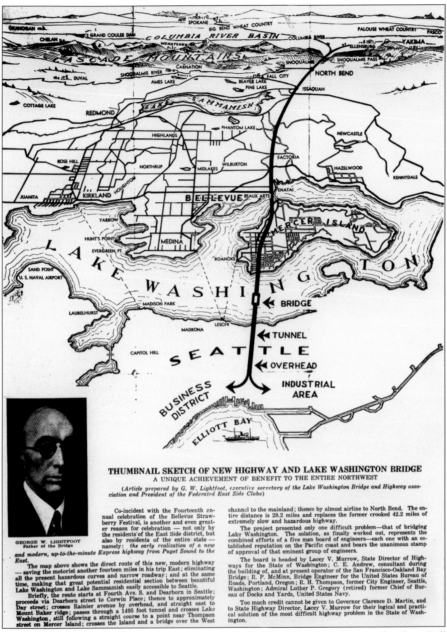

THUMBNAIL SKETCH OF NEW HIGHWAY AND LAKE WASHINGTON BRIDGE
A UNIQUE ACHIEVEMENT OF BENEFIT TO THE ENTIRE NORTHWEST

(Article prepared by G. W. Lightfoot, executive secretary of the Lake Washington Bridge and Highway association and President of the Federated East Side Clubs)

GEORGE W. LIGHTFOOT
Father of the Bridge

Co-incident with the Fourteenth annual celebration of the Bellevue Strawberry Festival, is another and even greater reason for celebration by the residents of the East Side district, but also by residents of the entire state — namely: *the early realization of a new and modern, up-to-the-minute Express highway from Puget Sound to the East.*

The map above shows the direct route of this new, modern highway — saving the motorist another fourteen miles in his trip East; eliminating all the present hazardous curves and narrow roadway; and at the same time, making that great potential residential section between beautiful Lake Washington and Lake Sammamish easily accessible to Seattle.

Briefly, the route starts at Fourth Ave. S. and Dearborn in Seattle; proceeds via Dearborn street to Corwin Place; thence to approximately Day street; crosses Rainier avenue by overhead, and straight east to Mount Baker ridge; passes through a 1495 foot tunnel and crosses Lake Washington, still following a straight course to a point near Thompson street on Mercer Island; crosses the Island and a bridge over the West

channel to the mainland; thence by almost airline to North Bend. The entire distance is 28.2 miles and replaces the former crooked 42.2 miles of extremely slow and hazardous highway.

The project presented only one difficult problem—that of bridging Lake Washington. The solution, as finally worked out, represents the combined efforts of a five man board of engineers—each one with an established reputation on the Pacific coast and bears the unanimous stamp of approval of that eminent group of engineers.

The board is headed by Lacey V. Murrow, State Director of Highways for the State of Washington; C. E. Andrew, consultant during the building of, and at present operator of the San Francisco-Oakland Bay Bridge; R. P. McMinn, Bridge Engineer for the United States Bureau of Roads, Portland, Oregon; R. H. Thompson, former City Engineer, Seattle, Washington; Admiral Luther P. Gregory (retired) former Chief of Bureau of Docks and Yards, United States Navy.

Too much credit cannot be given to Governor Clarence D. Martin, and to State Highway Director, Lacey V. Murrow for their logical and practical solution of the most difficult highway problem in the State of Washington.

BIG PLANS FOR A BRIDGE. As the eastern side of Lake Washington began to develop, Bellevue remained the last area to move beyond agriculture. It was simply too inconvenient to take the ferry or drive around the lake to commute to Seattle. A bridge would change that, making Bellevue instantly the most accessible part of the Eastside. Building a bridge across Lake Washington presented some major engineering challenges, however. The lake is too deep for pilings, and the adjacent shorelines are not conducive to suspension towers. The answer emerged in the 1930s with the daring plan to build a concrete pontoon bridge. This article, written for the community clubs of the Eastside, already anticipates the benefits of the bridge, predicting that it would make "that great potential residential section between beautiful Lake Washington and Lake Sammamish easily accessible to Seattle."

A NEW WAY OF LIVING. Seattle in the 1940s was a gritty place. The mills and shipyards of the Duwamish, the port activities of the waterfront, and fishing-industry facilities of the Ship Canal made for a lot of noise, dust, smell, and general unpleasantness. The early boosters of Bellevue knew this, and offered not just expanses of new housing but also, as the chamber of commerce brochure touts, "A New Way of Living!" Seattle had always prided itself on its beautiful, natural environment, but the crowded neighborhoods of the city made that less of a reality for most residents. Bellevue, however, could bring back that ideal of living with the trees and the water while still allowing an easy 20-minute commute to the jobs of Seattle.

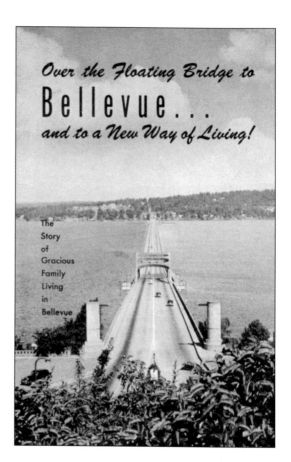

Over the Floating Bridge to
Bellevue...
and to a New Way of Living!

The Story of Gracious Family Living in Bellevue

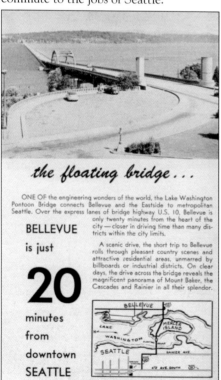

the floating bridge...

ONE OF the engineering wonders of the world, the Lake Washington Pontoon Bridge connects Bellevue and the Eastside to metropolitan Seattle. Over the express lanes of bridge highway U.S. 10, Bellevue is only twenty minutes from the heart of the city — closer in driving time than many districts within the city limits.

BELLEVUE
is just
20
minutes from downtown SEATTLE

A scenic drive, the short trip to Bellevue rolls through pleasant country scenes and attractive residential areas, unmarred by billboards or industrial districts. On clear days, the drive across the bridge reveals the magnificent panorama of Mount Baker, the Cascades and Rainier in all their splendor.

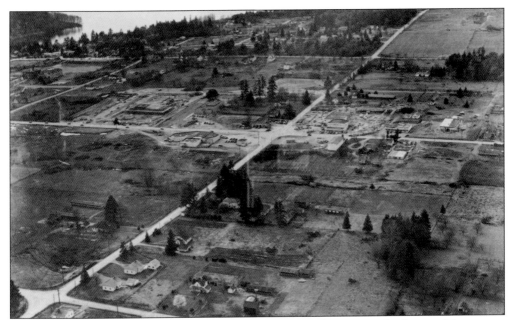

DOWNTOWN BELLEVUE, 1947. This view looks west over what is now the heart of downtown Bellevue. The first buildings of Bellevue Square are under construction, and a few businesses cluster around the intersection of 104th Avenue (now Bellevue Way) and Northeast Eighth Street in the center of the photograph. But otherwise, the landscape shows mostly scattered homes and pastures.

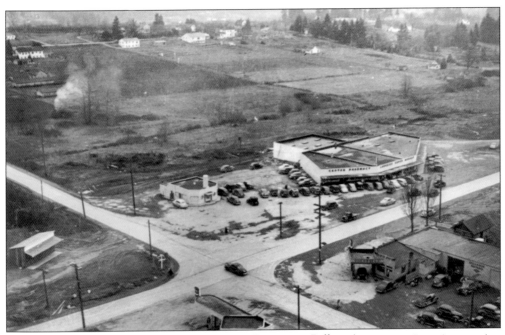

104TH AVENUE AND NORTHEAST EIGHTH STREET. Downtown Bellevue's most prominent intersection boasted three gas stations and no stoplights. It also had, on its southeast corner, the Lakeside Supermarket, among the first auto-oriented retailers off Main Street.

14

116TH AVENUE AND MAIN STREET. Outside of the immediate downtown core of Bellevue, things were still very rural. This photograph was taken from the site of the future Bellevue City Hall in the early 1950s and shows some development coming over the hill, but it does not yet show the impact of construction of Interstate 405, which replaced the smaller State Highway 2-A.

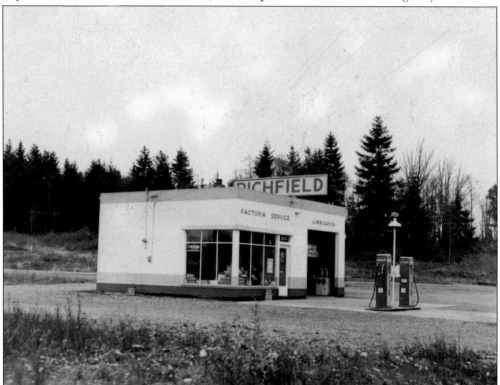

THE LONELY RICHFIELD STATION. Because everyone needs gas and because cars required a lot more regular service in those days, gas stations dotted the Eastside before other businesses had a chance to move in. This commercial outpost was in the Factoria area, south of Bellevue.

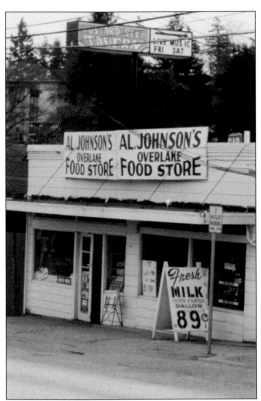

AL JOHNSON'S MARKET. A.C. Johnson and his son Al Jr. ran this market on Main Street that was typical of the small retailers that met local needs. Built in 1910, it originally housed Stream's Market.

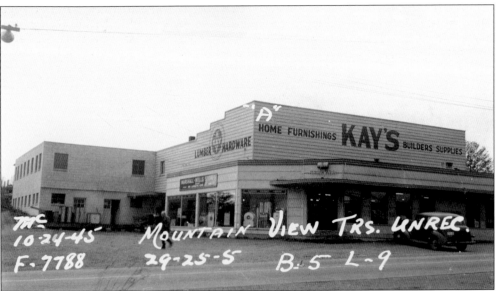

KAY LUMBERYARD AND HARDWARE STORE. Started in 1936, Kay's became a prominent fixture on the northwest corner of the intersection of Northeast Eighth Street and 104th Avenue. Cameron (Kay) Neumann opened the lumber and building-supplies store on land owned by James Ditty that had once been covered in apple orchards. After World War II, more businesses opened in this area. Kay also operated the neighboring Lakeside Center, which at the time offered the largest paved parking lot in King County. (Courtesy of the Washington State Archives.)

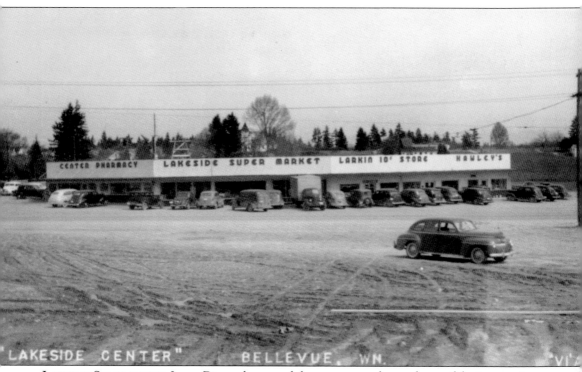

LAKESIDE SUPERMARKET. James Ditty, who owned the property to the southeast of the intersection of Northeast Eighth Street and 104th Avenue, had big plans. He envisioned a highly developed city with skyscrapers, airfields, factories, and other features of urban life. He began his plans modestly with the Lakeside Supermarket and expanded his properties on the site over the years. Many laughed at Ditty's dreams, but in the end, he proved highly prescient, as much of what he anticipated has come true.

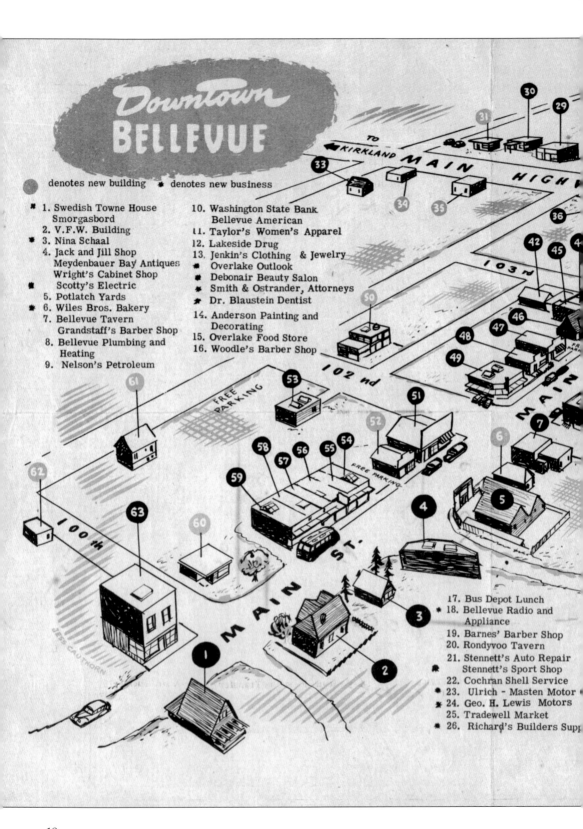

Downtown BELLEVUE

● denotes new building ✱ denotes new business

✱ 1. Swedish Towne House
 Smorgasbord
 2. V.F.W. Building
✱ 3. Nina Schaal
 4. Jack and Jill Shop
 Meydenbauer Bay Antiques
 Wright's Cabinet Shop
✱ Scotty's Electric
 5. Potlatch Yards
✱ 6. Wiles Bros. Bakery
 7. Bellevue Tavern
 Grandstaff's Barber Shop
 8. Bellevue Plumbing and
 Heating
 9. Nelson's Petroleum

 10. Washington State Bank
 Bellevue American
 11. Taylor's Women's Apparel
 12. Lakeside Drug
 13. Jenkin's Clothing & Jewelry
✱ Overlake Outlook
✱ Debonair Beauty Salon
✱ Smith & Ostrander, Attorneys
✱ Dr. Blaustein Dentist
 14. Anderson Painting and
 Decorating
 15. Overlake Food Store
 16. Woodle's Barber Shop

 17. Bus Depot Lunch
✱ 18. Bellevue Radio and
 Appliance
 19. Barnes' Barber Shop
 20. Rondyvoo Tavern
 21. Stennett's Auto Repair
✱ Stennett's Sport Shop
 22. Cochran Shell Service
✱ 23. Ulrich - Masten Motor
✱ 24. Geo. H. Lewis Motors
 25. Tradewell Market
✱ 26. Richard's Builders Supp

18

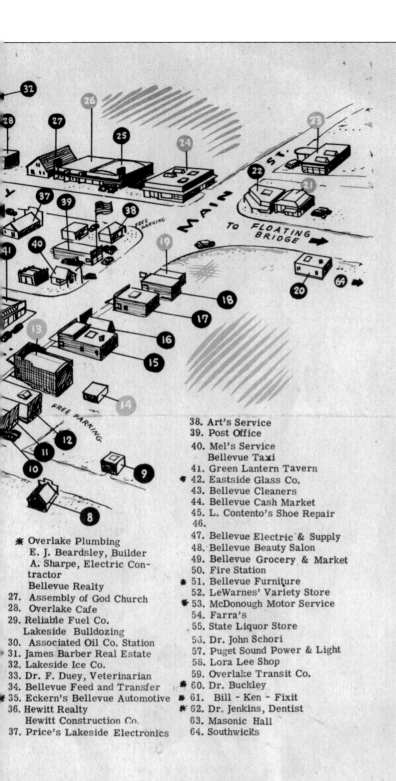

DOWNTOWN BELLEVUE, 1946. Although new businesses were taking shape to the north, Bellevue considered its downtown to be the areas along and adjacent to Main Street. This 1946 map shows 64 businesses in the blocks between Main Street and Northeast Fourth Street. Most of these businesses were small operations, and the illustrator did not hide the equally modest nature of the buildings. Nonetheless, it is clear that early on Bellevue would be considered moderately self-sufficient in goods and services. The problem was one of scale, and as the area began to grow, the old Main Street business district would not have the space—or the parking—to meet the needs of the new families on the way.

38. Art's Service
39. Post Office
40. Mel's Service
Bellevue Taxi
41. Green Lantern Tavern
✻ 42. Eastside Glass Co.
43. Bellevue Cleaners
44. Bellevue Cash Market
45. L. Contento's Shoe Repair
46.
47. Bellevue Electric & Supply
48. Bellevue Beauty Salon
49. Bellevue Grocery & Market
50. Fire Station
✻ 51. Bellevue Furniture
52. LeWarnes' Variety Store
✻ 53. McDonough Motor Service
54. Farra's
55. State Liquor Store
56. Dr. John Schori
57. Puget Sound Power & Light
58. Lora Lee Shop
59. Overlake Transit Co.
✻ 60. Dr. Buckley
✻ 61. Bill - Ken - Fixit
✻ 62. Dr. Jenkins, Dentist
63. Masonic Hall
64. Southwicks

✻ Overlake Plumbing
E. J. Beardsley, Builder
A. Sharpe, Electric Contractor
Bellevue Realty
27. Assembly of God Church
28. Overlake Cafe
29. Reliable Fuel Co.
Lakeside Bulldozing
30. Associated Oil Co. Station
31. James Barber Real Estate
32. Lakeside Ice Co.
33. Dr. F. Duey, Veterinarian
34. Bellevue Feed and Transfer
✻ 35. Eckern's Bellevue Automotive
36. Hewitt Realty
Hewitt Construction Co.
37. Price's Lakeside Electronics

OVERLAKE ELEMENTARY SCHOOL. This stately building on 102nd Avenue was among the last projects built in Washington State by the Works Projects Administration (WPA). It opened in 1942, replacing an older downtown elementary school. Renamed Bellevue Elementary School in 1950, it became the administrative offices for the Bellevue School District in the 1960s and was torn down in 1985 to make way for the Bellevue Downtown Park.

UNION S HIGH SCHOOL. The six school districts that covered the greater Bellevue area had merged in 1942 to create the Overlake School District, but the area still had just one small high school, the Union S school, which was then called Overlake High School. It had opened in 1930 on what is now the Bellevue Downtown Park and served high school students from the entire district. When the new Bellevue High School opened in 1949, the old building was to be converted to Bellevue Junior High School. The building was later used by Eastside Catholic High School and, like Overlake Elementary School, was torn down to make room for the Bellevue Downtown Park.

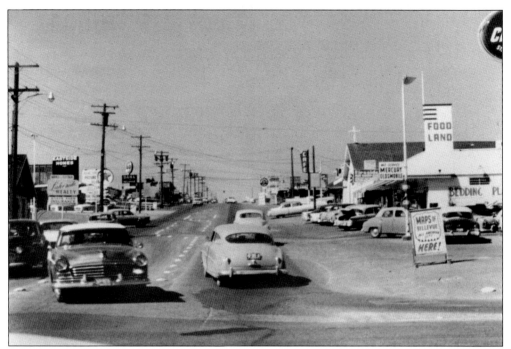

MAIN STREET AND 104TH AVENUE. In this mid-1950s photograph, 104th Avenue is starting to take on the look of a busy suburban commercial district, although it is still a two-lane road. New businesses, most noticeably the bank on the left, have emerged since the illustration of 1946. (Courtesy of the Washington State Archives.)

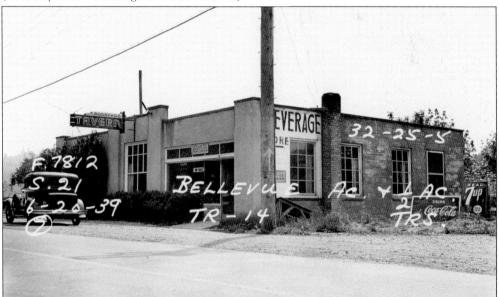

THE RONDYVOO TAVERN. In its prewar days, Bellevue may have lacked many essential services, but it did not have a shortage of places to wet one's whistle. Main Street had several taverns, and just to the south on 104th Avenue stood the Rondyvoo Tavern, shown here in 1939. Although it probably got paid to advertise soft drinks, it is unlikely that many patrons came in for a Coke. (Courtesy of the Washington State Archives.)

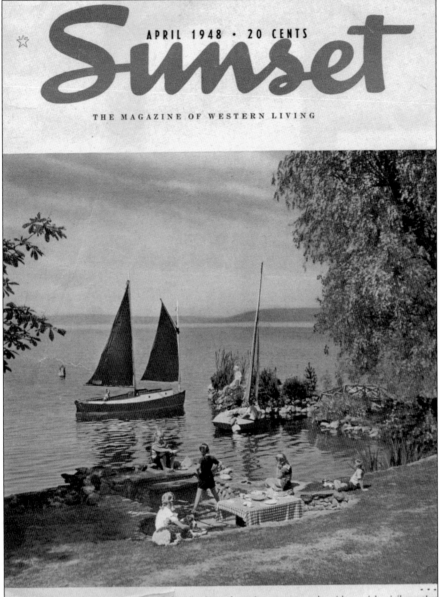

APRIL 1948 · 20 CENTS

Sunset

THE MAGAZINE OF WESTERN LIVING

The Pacific Northwest has the habit of favoring some homesites so generously with special privileges that envy comes easy to those living elsewhere. But credit Dr. and Mrs. F. Klopfer of Bellevue, Washington, for making good use of Lake Washington. The fireplace-grill overhangs the lake so that waves break away from it

GRACIOUS LIVING. In 1948, *Sunset Magazine* recognized that something special was happening on the east side of Lake Washington. Waterfront property, like this home on Yarrow Point, was not inexpensive, but it was also not out of reach for the region's growing professional and managerial classes. The new bridge had made lakefront property, and other areas with fine views and pristine forests, accessible for commuters. As the region's economy finally broke out of its postwar slump, Bellevue would rapidly move out of its rural origins and become the hub for this "New Way of Living." The children in the photograph, from left to right, are Karen Martin, Daphne Morns, Marilyn Brown, Linda Eastham, Myra Moberg, Bob Tuck, Kay Moberg, and Dick Martin. (Courtesy of Sunset Magazine.)

Two

GETTING TO AND THROUGH BELLEVUE

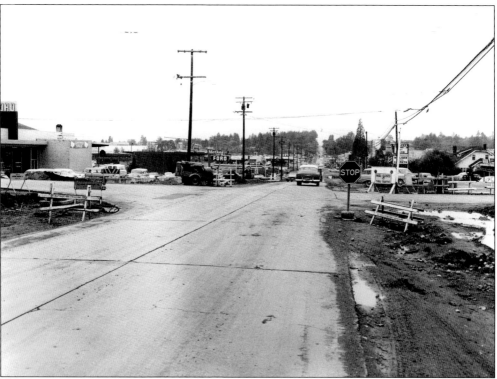

ROAD WORK FOR THE NEW CITY. Bellevue had grown up as part of unincorporated King County and was considered a largely rural area with few road needs. The county built arterials but did not have any real strategic sense of how the area might evolve. Once the city incorporated in 1953, among the first tasks was to address the inadequate road network of the downtown area. This photograph shows the intersection of 108th Avenue and Northeast Eighth Street in the mid-1950s, when all downtown streets were no more than two lanes and many were still unpaved. The decade that followed would see massive road building to create the network that exists largely intact today. (Courtesy of the Washington State Archives.)

ARRIVING FROM THE NORTH. By the late 1800s, Kirkland was already a thriving city, built around Peter Kirk's dreams of creating the "Pittsburgh of the West," so residents of the Bellevue area became accustomed to heading north for a wider selection of stores and entertainment. This photograph looking north from about Northeast Twelfth Street shows what is now Bellevue Way after it had been freshly paved in the late 1950s. (Courtesy of the Washington State Archives.)

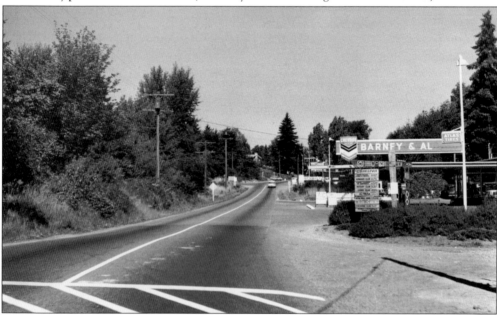

FROM THE SOUTH. Prior to completion of the bridge to Seattle, the route across the East Channel went through Enatai and was lightly travelled. Once the bridge was completed, however, the route from the south became a main thoroughfare. This photograph shows the intersection of what is today Bellevue Way and 108th Avenue Southeast. A service station still occupies the narrow corner. (Courtesy of the Washington State Archives.)

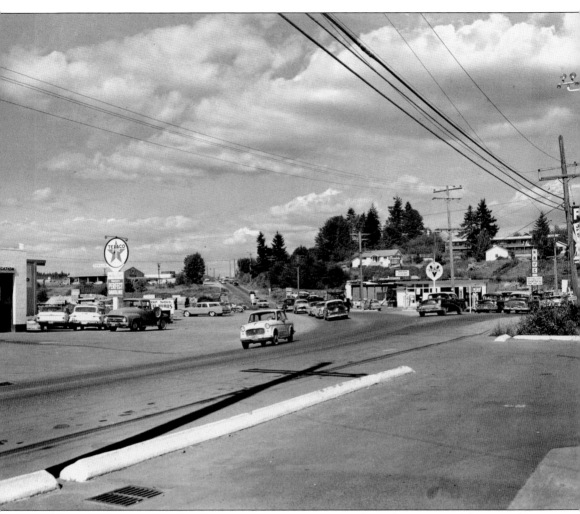

FROM THE EAST. Prior to its reconfiguration in the 1970s, the Bellevue-Redmond Road merged with Northeast Eighth Street in Midlakes. This photograph looks east on Northeast Eighth Street and up Bel-Red Road. (Courtesy of the Washington State Archives.)

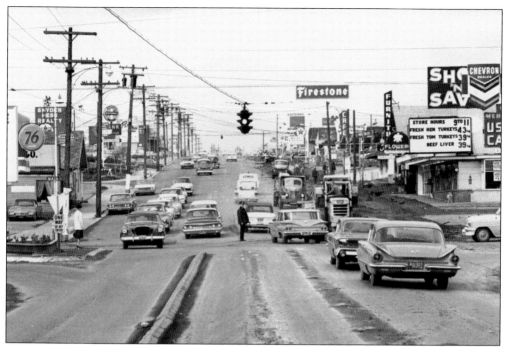

BEFORE AND AFTER, 104TH AVENUE AND MAIN STREET. By the early 1960s, when these photographs were taken, 104th Avenue had grown into a major commercial road in addition to being the only north-south route through the entire city. The jumble of utility poles did not add to its appeal. The complete rebuild, as seen in the photograph below, widened the street, buried the power lines, and added capacity heading south. In the photograph above, Bellevue police officer Don Lapthorne braves the traffic to keep things moving. (Both, courtesy of the Washington State Archives.)

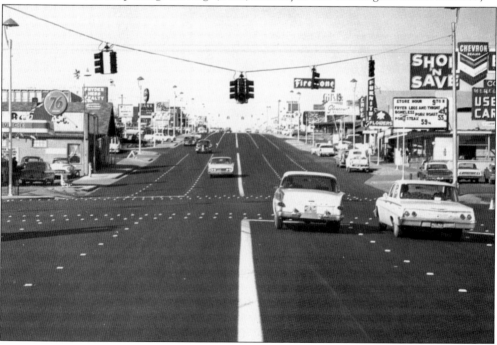

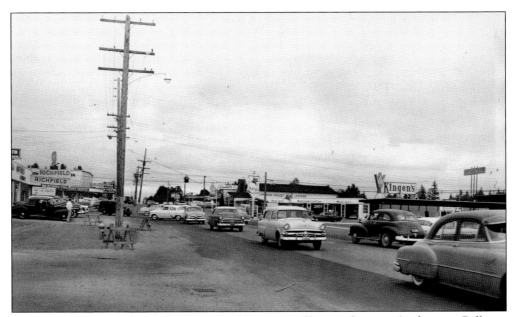

BEFORE AND AFTER, 104TH AVENUE AND NORTHEAST EIGHTH STREET. At the time Bellevue incorporated, the city's main commercial street looked like the photograph above, with the original two-lane county road flanked by parking strips and access roads. Several years later, the upgrade process caught up with this stretch of road, and it became a six-lane arterial with buried utilities and a complete set of sidewalks and streetlights. In the intervening years, Kingen's Drive-In had changed to the Carnival, and the gas station on the corner had shifted from Richfield to Texaco products. The Lakeside Frozen Food Lockers remained through it all. (Both, courtesy of the Washington State Archives.)

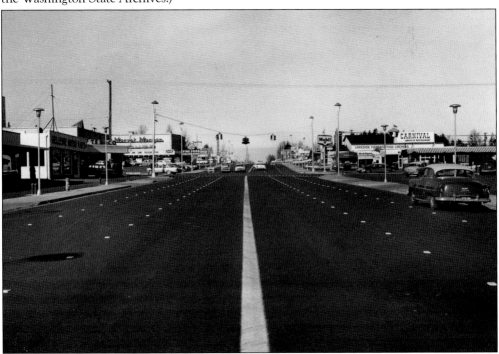

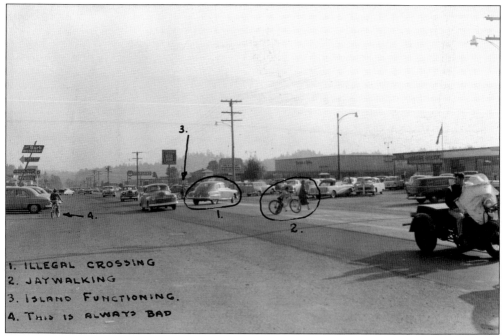

1. ILLEGAL CROSSING
2. JAYWALKING
3. ISLAND FUNCTIONING.
4. THIS IS ALWAYS BAD

TACKLING SAFETY PROBLEMS. Prior to incorporation, Bellevue's road system was run by King County, which did not have the resources to upgrade the network to make it work for a growing commercial area. The photograph above, taken from a 1955 study of traffic patterns on 104th Avenue, shows the safety problems that the new city needed to remedy. The photograph below, taken from the opposite direction, shows the newly expanded road and the entrance to the now-larger Bellevue Square. (Both, courtesy of the Washington State Archives.)

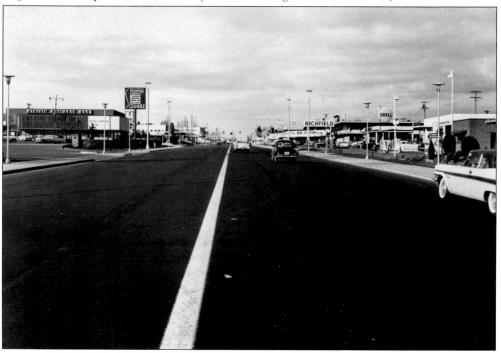

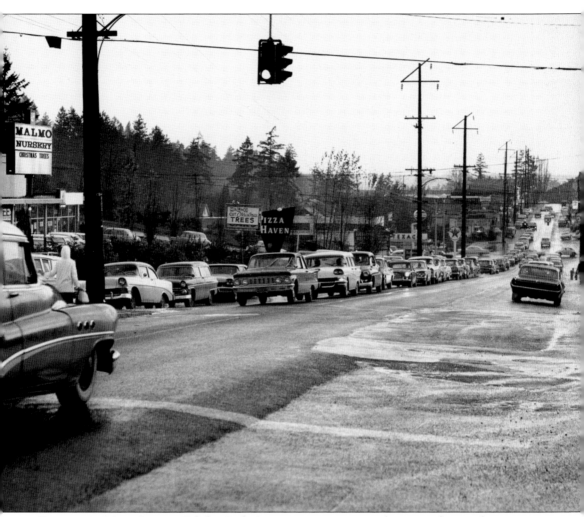

TRAFFIC ON MAIN STREET. While 104th Avenue was getting a makeover and expanding to six lanes, Main Street remained a two-lane road. This photograph, taken at the intersection of Main Street and 106th Avenue in the late 1950s, shows backups well past 104th Avenue. The children walking in the street on the right illustrate the safety problems that the city confronted as its rapidly expanding commercial areas outstripped the old, rural road network it inherited. But freshly cut Christmas trees were available at the Ernst-Malmo Nursery on the left. (Courtesy of the Washington State Archives.)

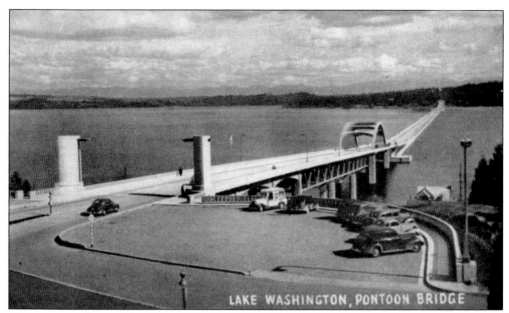

LAKE WASHINGTON, PONTOON BRIDGE

CROSSING THE LAKE. The importance to Bellevue's history of the floating bridge across Mercer Island cannot be overstated. Nor can the importance of the engineering feat that created the bridge. Originally conceived as a way to create a faster route to the east across the Cascade Mountains, the bridge, shown here from the Seattle side, had the more immediate effect of providing access to the large developable areas across the lake.

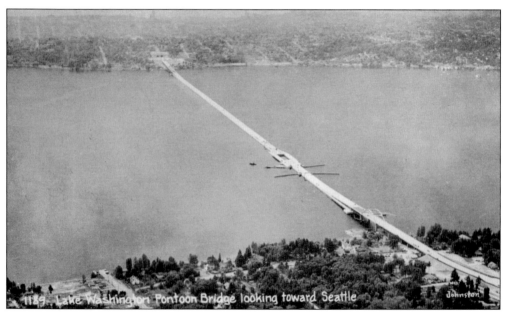

1189. Lake Washington Pontoon Bridge looking toward Seattle Johnston

THE "BULGE." No story of the floating bridge is complete without mention of the infamous "bulge" in mid-span. Lake Washington is a navigable waterway, and the Coast Guard required that the bridge accommodate large vessels that could not fit under the high-rises on the ends. The solution was a draw span that floated into the space in the bulge. The tight curves in the lanes were a menace for drivers, especially when the reversible lane opened during rush hour.

THE SR-520 BRIDGE. Within 10 years of its opening, the Mercer Island floating bridge was already becoming crowded, and the state began to plan for a second bridge. After a decade of debate, the Montlake-to-Medina route was chosen, and the new bridge opened in 1963, doubling cross-lake capacity. With the new interstate routes opening in Seattle and the Eastside, Bellevue became highly accessible for commuters going in both directions and started to look like a place that might make a good employment center some day. (Courtesy of the Seattle Post-Intelligencer Collection, Museum of History and Industry.)

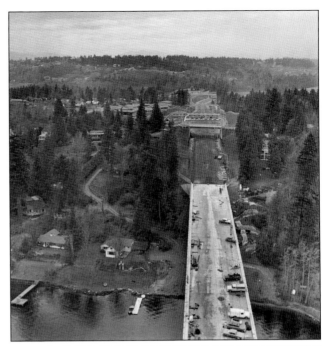

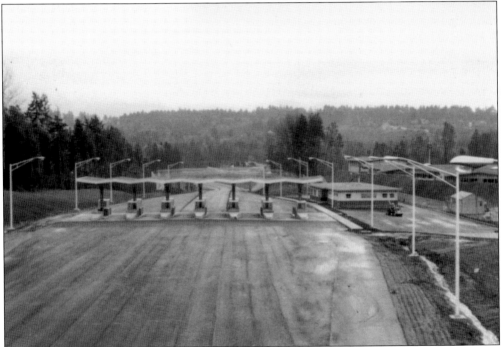

SR-520 TOLLBOOTHS. Although the federal government paid nearly all of the cost of the interstate system, the SR-520 bridge was not part of that network and had to be financed locally. That meant tolls. Those with cash paid 35¢ each way, and commuters could buy ticket books for 19¢ per trip. When the state began to promote carpooling during the oil crisis of 1973, it lowered the toll to 10¢ for cars with two or more people. Tolls came off in 1979 as the state paid off construction bonds well ahead of schedule. (Courtesy of the Washington State Archives.)

Jan.	Feb.	Mar.	Apr.	May	J●	July	Aug.	Sep.	Oct.	Nov.	Dec.			806233	
1	2	3	4	5	6	7	8	9	10	11	12	13	14	15	
16	17	18	19	20	21	2●	23	24	25	26	27	28	29	30	31

ONE TRIP

AUTO and PASSENGERS

Tickets void after day and month designated above.
Tickets are to be detached by Collector.

| | 1978 | ●9 |

SUBJECT TO CONDITIONS PRINTED ON COVER
WASHINGTON STATE HIGHWAY COMMISSION
DEPARTMENT OF HIGHWAYS

SR-520 TOLL TICKET. SR-520 commuters always had a book of toll tickets tucked in their visor. To make sure they were used only by commuters, tickets had an expiration date. To discourage sharing of tickets by noncommuters, the book states that the ticket must be removed from the book by the toll taker. This requirement was rarely, if ever, enforced, and occasional users of the bridge could always get a ticket from a neighbor.

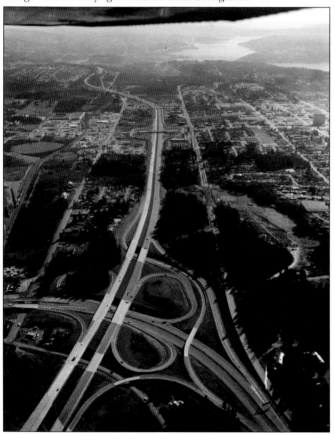

INTERSTATE 405-SR-520 INTERCHANGE. When the SR-520 bridge opened in 1963, it connected to the newly completed section of the highway that would become Interstate 405, just north of Bellevue. This completed a loop that linked Bellevue with the University of Washington and downtown Seattle. The rest of SR-520 would be completed in stages, reaching Overlake by 1972 and Redmond by 1979. (Courtesy of the Washington State Archives.)

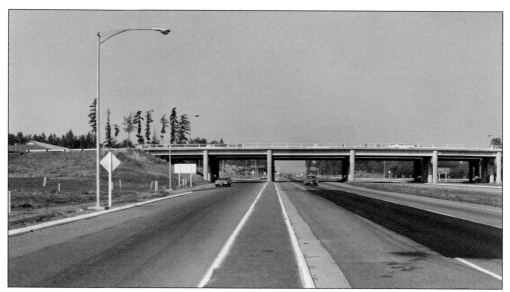

INTERSTATE 405 THROUGH BELLEVUE. The interstate highway system, originally justified as a way to move military vehicles during the Cold War, consisted of spine routes and local spurs and bypasses. Along the West Coast, Interstate 5 served as the spine. In the Seattle area, only one bypass was built, Interstate 405, which was an improvement on the original State Highway 2A. The critical Bellevue-to-Tukwila section opened in 1965, and the full route from Lynnwood to Tukwila was completed to interstate standards by 1971. (Courtesy of the Washington State Archives.)

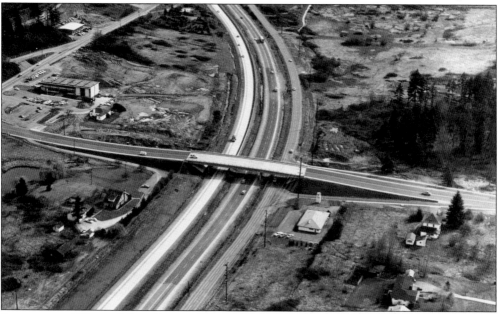

INTERSTATE 405 AND MAIN STREET. When it was first built, Interstate 405 ran through some very sparsely populated territory, fulfilling its intended purpose as a bypass for the more crowded Interstate 5 through Seattle. But it did not take long for Interstate 405 to fill up with commuters heading from Bellevue to the massive Boeing operations in Renton and the Kent Valley. And despite repeated expansions, the entire freeway remains congested for much of the day. (Courtesy of the Washington State Archives.)

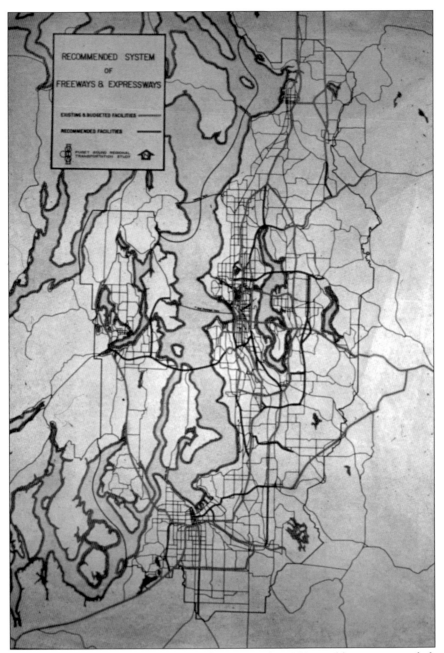

FREEWAYS, FREEWAYS, AND MORE FREEWAYS. Planners in the 1950s could not get enough freeways on the books. This plan shows anticipated freeways throughout the region, including a new Sand Point–to-Kirkland bridge and a freeway along the 148th Avenue corridor in Bellevue. In spite of all these ambitious plans, including a later push for a new Interstate 605 running east of Lake Sammamish, the region's freeway network was largely in place by the late 1960s. The challenge became one of fixing the design problems, such as very short merge distances, that inexperienced engineers had built into the early freeways. By the 1990s, the debate had shifted from new corridors to the need to fix choke points in the network that, for better or worse, is the only one the Eastside will likely ever have.

Three

GOING TO SCHOOL

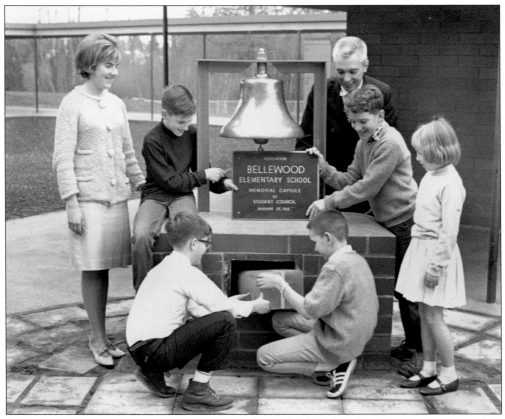

WHERE HOPES AND IDEALS ARE HIGH. So said a reader board at the foot of Kilmarnock Way in the 1960s, summing up the aspirations of Bellevue for its children. In the post–World War II years, Bellevue was built around families and children, and schools were at the center of that world. Community leaders of the 1950s inherited a patchwork of rural schools that had served the sparsely populated area well but fell far short of what would be needed as the baby boomers started to fill classrooms. With high hopes and ideals, they set about building a school system that has become among the best in the state and the nation. In this photograph, student leaders at the brand-new Bellewood Elementary School place a time capsule under the school bell in January 1966. (Courtesy of the Washington State Archives.)

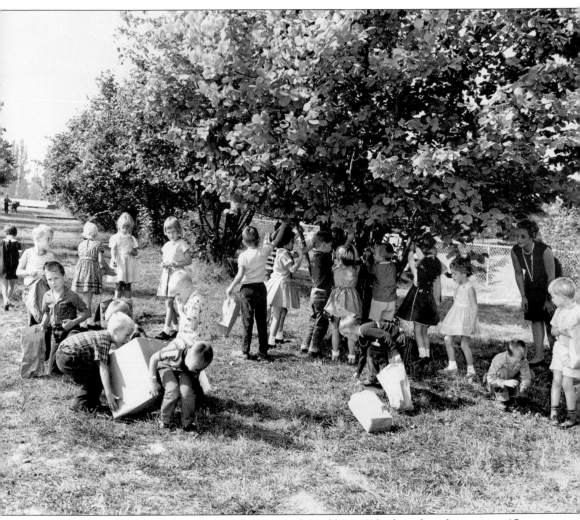

ALL ABOUT THE KIDS. The Great Depression and World War II had combined to create a 15-year period in which optimism was hard to come by, which made starting a family an uncertain undertaking. The end of the war and the return of prosperity meant a resurgent optimism and the onset of the baby boom. Those who had fought in and supported the war effort were ready to settle down to domestic life, and the new suburban areas were ideally suited to raising families. However, they needed an infrastructure that was lacking, and communities set about building schools, parks, and recreation programs to go along with the cul-de-sacs and big backyards. In this photograph, children gather filbert nuts from trees at Surrey Downs Elementary School. (Courtesy of the Washington State Archives.)

We welcome your interest in the Bellevue school system. Bellevue offers to the career teacher an opportunity to live and work in a forward-looking community which takes great pride in its schools. Attractive, well-maintained buildings with up-to-date furnishings provide an ideal environment for the professional teacher. Extensive teacher services, an excellent salary schedule, and a cooperative and friendly community characterize the Bellevue Public Schools.

RECRUITING TEACHERS. All the new school buildings that arose in the 1950s needed teachers, but the baby boom was not limited to Bellevue, and teachers were in demand everywhere. Bringing top talent to the Eastside became a major priority for the rapidly growing Bellevue School District. The brochure above invites educators to come to "a teachers town," where they would have "an opportunity to live and work in a forward-looking community which takes great pride in its schools." Realizing that Bellevue would seem somewhat remote, the brochure notes that it is "only fifteen minutes from the cultural, intellectual and recreational resources of Seattle." The photograph below shows Sandra McCarthy, a teacher at Wilburton Elementary School during the 1965–1966 school year. (Both, courtesy of the Washington State Archives.)

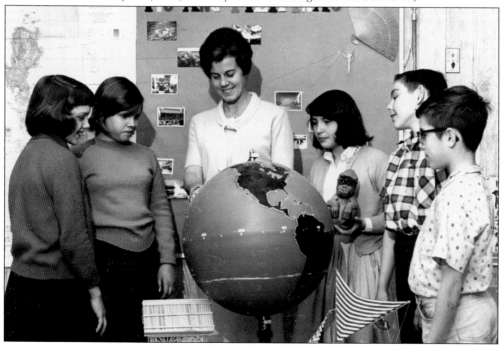

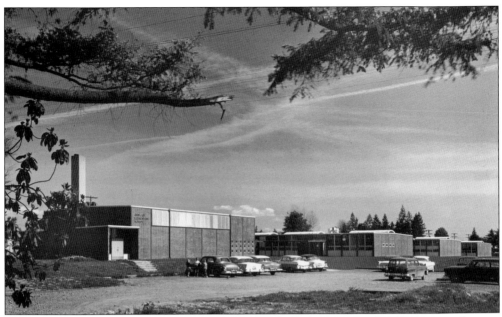

ASHWOOD AND HILLAIRE SCHOOLS. These two schools, built in 1956 and 1962 respectively, were part of a school-building boom in which the Bellevue School District completed 25 elementary schools in 20 years. Most of these facilities were built with an open plan that took advantage of inexpensive, flat land to create one-story complexes with classrooms opening onto open-air courtyards and breezeways. This type of structure was inexpensive and fast to build, and most schools were designed for two classrooms per grade. This design concept did not age well, however, and by the 1990s the district began to replace the aging structures completely with larger, two-story complexes. (Both, courtesy of the Washington State Archives.)

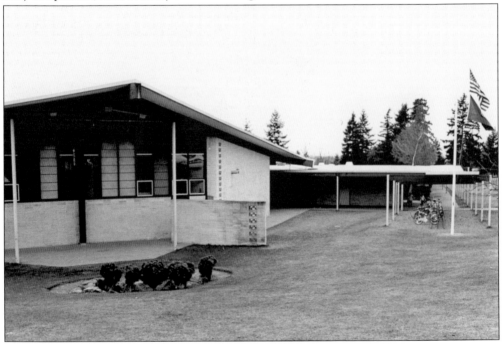

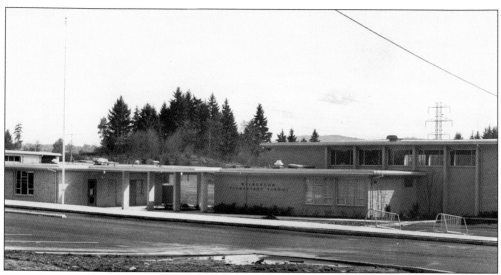

WILBURTON AND ROBINSWOOD SCHOOLS. Almost as quickly as the children arrived in the 1950s and 1960s, they began to disappear in the 1970s and 1980s. The baby boom that lasted until 1964 was followed by the baby bust, and fewer children headed to school. By the 1970s, the area covered by the Bellevue School District had largely been built out, and the families that moved to the area in the 1950s were still in their homes, but as empty nesters. So, beginning in 1978, the district began to close schools. Some, such as Ashwood Elementary and Bellevue Junior High, were demolished for other uses, but most became private schools or, as with the schools in these photographs, were repurposed. Wilburton, closed in 1983, became a school district training center. Robinswood, also closed in 1983, was used by Bellevue Community College and later became an alternative high school. (Both, courtesy of the Washington State Archives.)

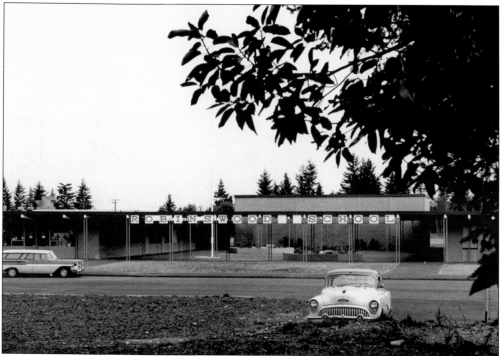

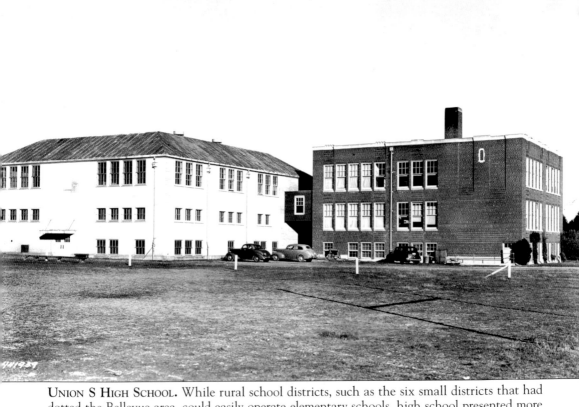

UNION S HIGH SCHOOL. While rural school districts, such as the six small districts that had dotted the Bellevue area, could easily operate elementary schools, high school presented more of a challenge. One solution was for several small districts to join forces to create a "union" high school, which all of their children could attend. Districts in the Bellevue-Overlake area formed the Union S High School that opened in what is now the site of the Bellevue Downtown Park in 1930. Bellevue now had a real high school that would rival those in Kirkland and Renton. However, as the area started to grow in the postwar years, it would not be sufficient, and the new district made plans to replace it with a larger building away from the growing downtown core. (Courtesy of the Washington State Archives.)

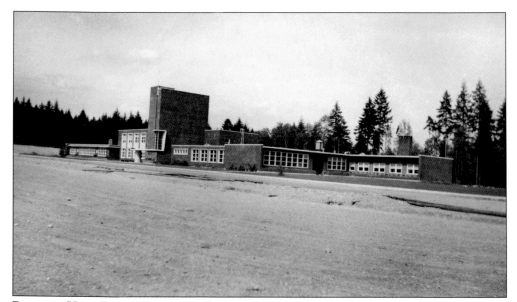

BELLEVUE HIGH SCHOOL. In 1946, with the Union S High School having been open for only 15 years, the newly formed Overlake School District board decided to acquire a site for a new high school. They chose a 49-acre site on Raine Hill and paid the owner $37,500. The new Overlake Senior High School opened for classes in January 1949.

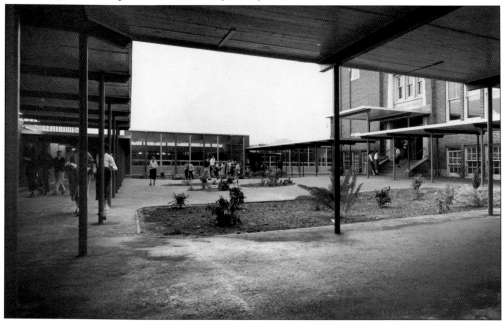

BELLEVUE JUNIOR HIGH SCHOOL. With the move of the high school to its new building in 1949, the old Union S facility was converted to Bellevue Junior High School. New, open-plan rooms were added to the old brick building. But the same demographic trends that resulted in closure of elementary schools led to the closure of junior high schools as well, and Bellevue Junior High School closed in 1979. For 10 years, it served as the campus for Eastside Catholic High School, and it was later demolished to make room for the Bellevue Downtown Park. (Courtesy of the Washington State Archives.)

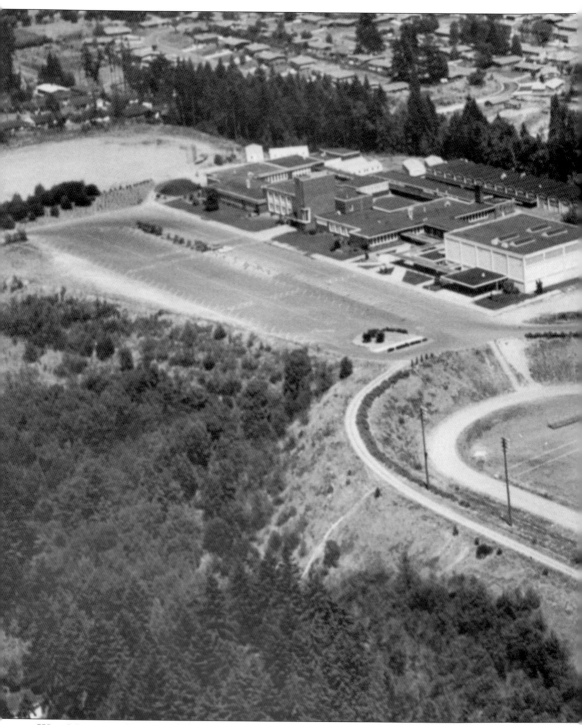

WAR MEMORIAL FIELD. While the new Bellevue High School (BHS) was taking shape, plans were underway for a war-memorial athletic field to be built on the new school site. The athletic complex opened in 1950, with local fans snapping up season tickets for $3.50 per seat. Although the school itself was almost entirely replaced in 2012, the Bellevue High School football team,

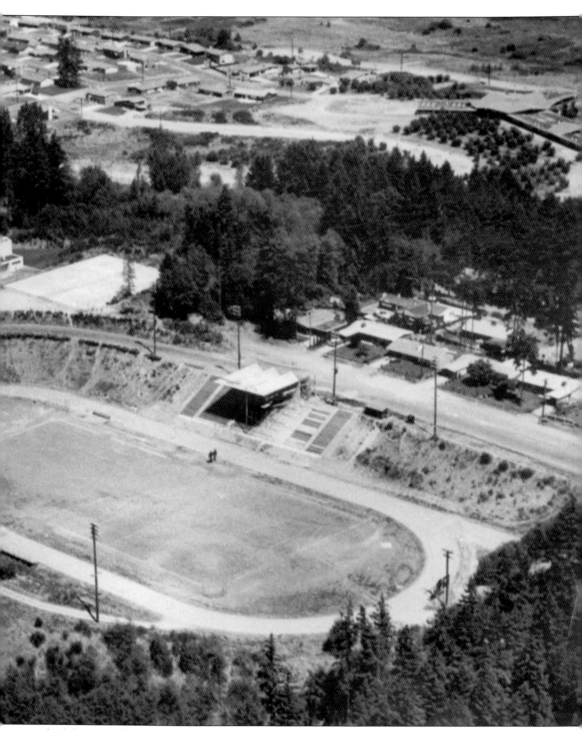

which has won the state AAA title nearly every year since 2000, still plays its home games at the field. As a gift to the school, the BHS class of 2000 worked with the city to have the road leading to the school renamed from Kilmarnock Way to Wolverine Way.

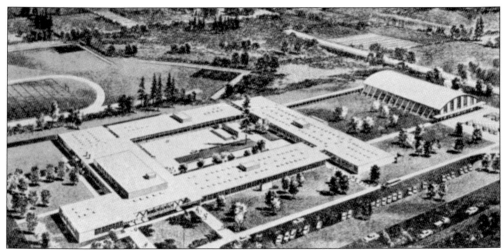

SAMMAMISH HIGH SCHOOL. The new Overlake High School (soon to become Bellevue High School) was a good start, but it would not be enough to keep up with the children who were rapidly moving through the elementary schools. Moreover, much of the growth in the district was taking place well to the east of the new school, making for long bus trips. In response, the district opened Sammamish High School in 1959 at the corner of 140th Avenue and Main Street, in the heart of the rapidly growing part of the district.

INTERLAKE HIGH SCHOOL. With the completion of the SR-520 bridge, growth in Bellevue shifted more to the north, and Sammamish High School could not handle all the new students. So in 1967, the district opened the last of its high schools, Interlake, on the corner of Northeast Twenty-fourth Street and 164th Avenue.

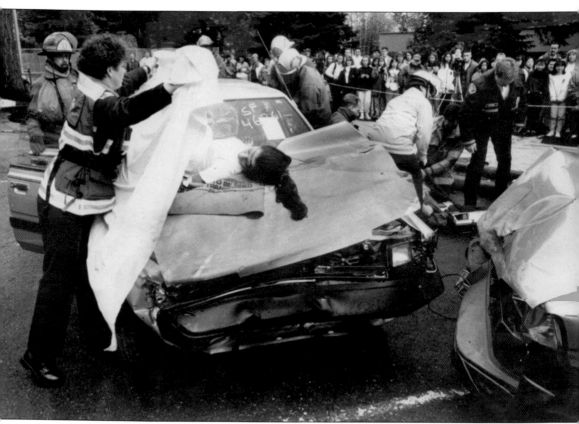

NEW DRIVERS. Suburban living has always centered on cars. Each year, hundreds of Bellevue students went through the rite of passage of drivers' education at their high school and those terrifying few months after going solo. This image shows student drivers at Interlake High School as they watch a fire department demonstration of what can result from carelessness behind the wheel.

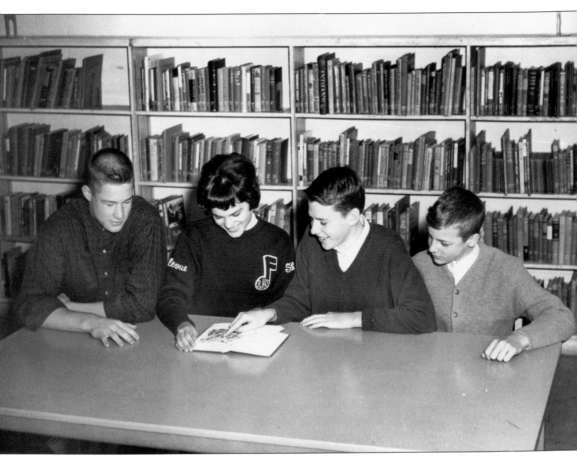

STUDENT GOVERNMENT. Shown in this photograph are Bellevue Junior High School student body officers for the 1962–1963 school year. From left to right are vice president Dave McClinton, secretary Sharon Griffith, president Paul Swindlay, and treasurer Hank Ricklefs. (Courtesy of the Washington State Archives.)

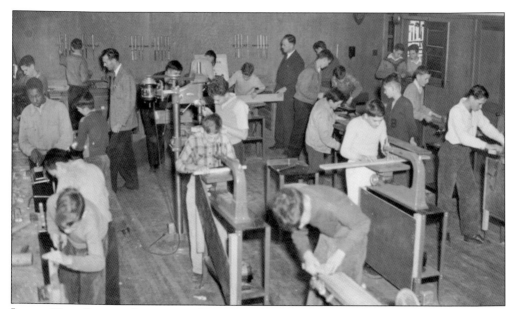

JUNIOR HIGH SCHOOL. In an era with generous funding, junior high schools could offer a wider range of courses and activities. The photograph above shows a shop class at Bellevue Junior High School in 1944. The photograph below shows the school's cheerleading squad in 1962, which would have been urging on teams from an athletic program that no longer exists at that grade level. The cheerleaders and many of the shop students would have been ninth graders, as the Bellevue School District did not shift to a middle school model (sixth through eighth grades) until 1985. (Above, from the collection of the Eastside Heritage Center; below, courtesy of the Washington State Archives.)

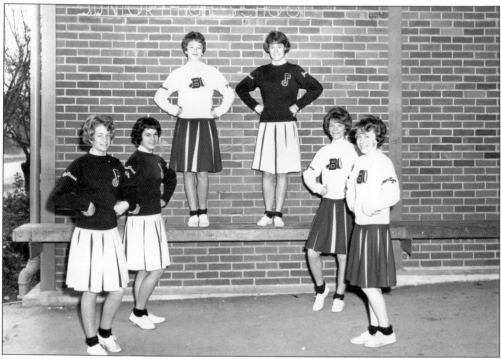

HIGH SCHOOL SPORTS. Bellevue school sports have long enjoyed success in regional leagues, with the high school basketball team winning the league championship shortly after joining in 1925. Shown here is the program for a 1954 game in which Bellevue boys took on Bothell.

Bothell "A" Squad				
Name	No.		Cl.	Age
Jack Kerwin *	4	6-4½	Sr.	17
Paul Ronhaar	3	6-6½	Sr.	18
Tom Kuntz	33	5-9	Sr.	18
Bud Rathe	88	5-10½	Sr.	17
Glen Prater *	55	5-11	Sr.	17
Harvey Taylor	66	5-10	Jr.	16
Bill Adair	44	6-2	Jr.	16
Charlie Engle	22	5-10	Jr.	17
Pat MacKay	99	5-8	Jr.	17
Bob Schulze	77	6-1	Jr.	16

Head Coache- Bob Knowles Managers-A. Tracy
Assit. Coache- Dar Seeley John Price
 Dick Sween
Mascot- COUGAR ! Frank Vittuli

Bellevue "A" Squad				
Name	No.	Ht.	Cl.	Age
Dave Bird	33	5-11	Sr.	17
Chuck Maletta	99	6-2	Sr.	17
Stan Stricklin	00	5-9	Jr.	16
Don Anacker	14	6-1	Jr.	16
Don Briedenstein	44	6-2	Sr.	17
Duncon Bronson	13	6-2	Sr.	17
Bill Crippen	77	6-2	Jr.	16
Dick Dana	11	5-9	Sr.	18
Doug Grant	55	6-0	So.	15
Bob Mash	66	5-10	Sr.	16
Bob Thees	22	5-11	Sr.	17
Don Osborn	88	5-11	Jr.	16

Colors- Blue & Gold

Bellevue VS. Lake Washington

OCTOBER 22, 1954

8 P. M.

BELLEVUE HIGH SCHOOL STADIUM

OFFICIAL PROGRAM—10¢

A—5

BELLEVUE HIGH SCHOOL FOOTBALL. Bellevue was victorious in this game against the Lake Washington Kangaroos, winning 15-12. Bellevue's storied football program has been dominant in Washington's AAA division since the 1990s and is considered one of the best teams in the nation.

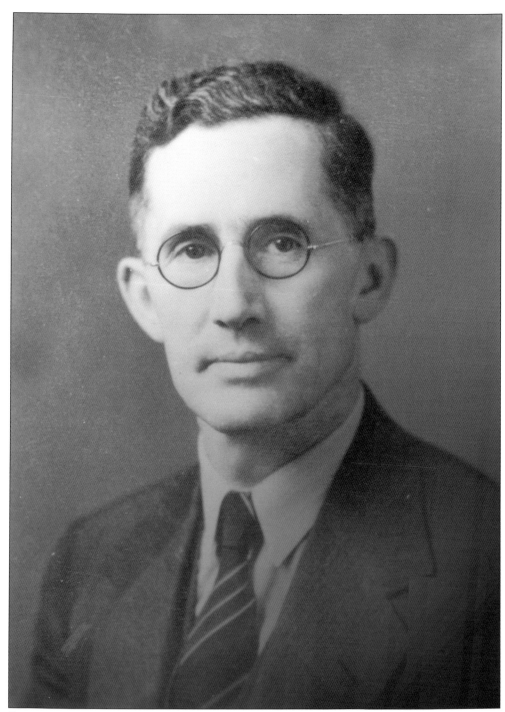

FRANK ODLE. M. Frank Odle became superintendent of Bellevue School District No. 49 in 1918. He also served as principal of the high school and coach of sports teams and later pitched in as a bus driver. After 50 years serving students in Bellevue, he retired in 1968. He passed away the following year and was honored immediately when the Bellevue School District named its newest school M. Frank Odle Junior High School.

50

Four

BUILDING NEW
NEIGHBORHOODS

OPEN LAND FOR NEW COMMUNITIES. When the suburban housing boom began, Bellevue offered a unique opportunity for home builders. It had very large tracts of open land that were easily linked by the new bridge to Seattle. Vuecrest, just to the northwest of the downtown core, was among the first developments, and the sales brochure emphasized the two key points that builders would stick to for a long time: proximity to Seattle, and "gracious living."

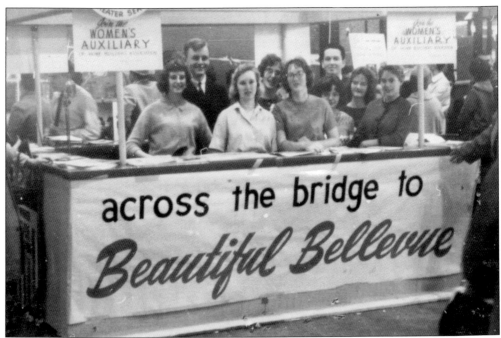

SELLING BELLEVUE AT THE HOME SHOW. The business community of Bellevue was never shy about promoting the delights of living across the lake. Bellevue had a regular appearance at the annual home show put on by the Home Builders Association. In the photograph above, Bellevue is represented by, from left to right, Janet Stahl, Mike VanAckern, Darlene Sonstegaard, Peggy Russell, Tina Holmberg, Carol Trumble, Tom Boswell, Donna Bush, and Karen Clark. By 1962, as pictured below, the message had shifted to the larger Eastside, which, with the imminent completion of the new SR-520 bridge, would be accessible to commuters.

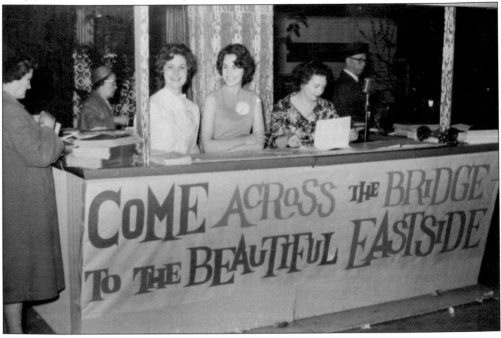

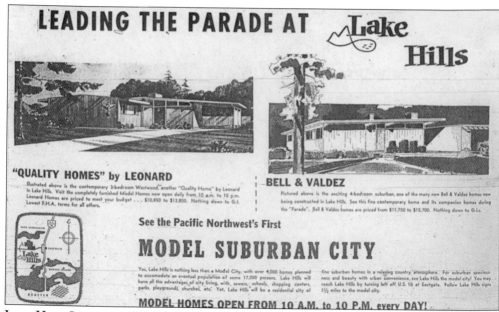

LAKE HILLS LEADS THE WAY. Of all the new communities started in the 1950s on the Eastside, Lake Hills comes most readily to mind. The firm of Bell & Valdez carved out hundreds of acres of forest and farmland just to the north of Route 10, which led to Seattle, and built thousands of homes in a very short period of time. Lake Hills was far enough from the older downtown core of Bellevue that it needed its own commercial centers, giving rise to several neighborhood shopping centers and then to the much larger Crossroads Shopping Center. The homes in Lake Hills were very standardized and modest in size, but they sold quickly. Lake Hills resisted annexation to Bellevue until the late 1960s, and, as a condition of annexation, insisted on having a local community council that had veto power over land-use decisions. (Above, from the collection of the Eastside Heritage Center; below, courtesy of the *Seattle Times*.)

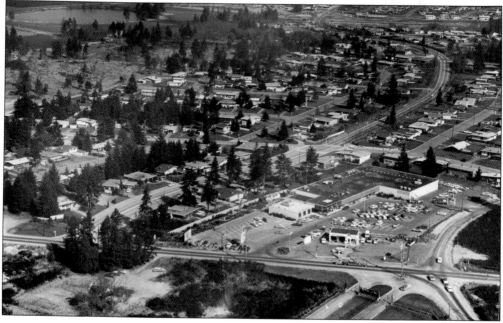

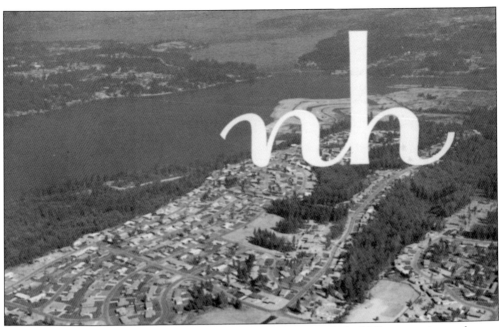

NEWPORT HILLS AND NEWPORT SHORES. At about the same time, Lake Hills was getting underway, development began on a hill to the south of Route 10. Boeing had begun to move large parts of its operations from Seattle to an old military plant in Renton, and the area between Route 10 and Renton became prime home-building territory. Newport Hills offered homes and neighborhoods similar to those found in Lake Hills (which did not actually have any hills) and also had a neighborhood shopping center. Then, enterprising developers saw potential in the swampy lakeshore below and built the Newport Shores development, complete with canals. The brochure cover above shows Newport Shores as the grading was complete.

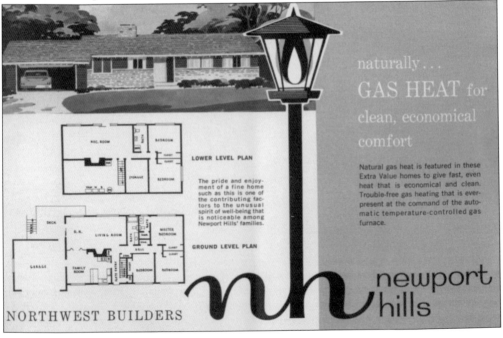

LOWER LEVEL PLAN

The pride and enjoyment of a fine home such as this is one of the contributing factors to the unusual spirit of well-being that is noticeable among Newport Hills' families.

GROUND LEVEL PLAN

naturally . . .
GAS HEAT for
clean, economical
comfort

Natural gas heat is featured in these Extra Value homes to give fast, even heat that is economical and clean. Trouble-free gas heating that is ever-present at the command of the automatic temperature-controlled gas furnace.

NORTHWEST BUILDERS

newport hills

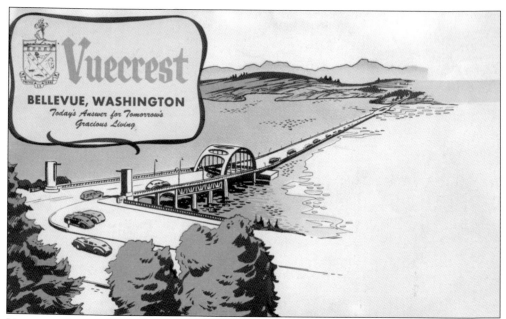

VUECREST. Among the first of the new developments in Bellevue was Vuecrest, built on the Patrick Downey family's 160-acre farm just to the northwest of the downtown core. Compared to the scale of developments that would follow to the east of Bellevue, it was modest in size. It featured a geometric layout that maximized views across the lake. It also had buried power lines and covenants to protect views. Time has been good to Vuecrest, and it remains a highly desirable neighborhood, with many of the original homes having been extensively remodeled or replaced.

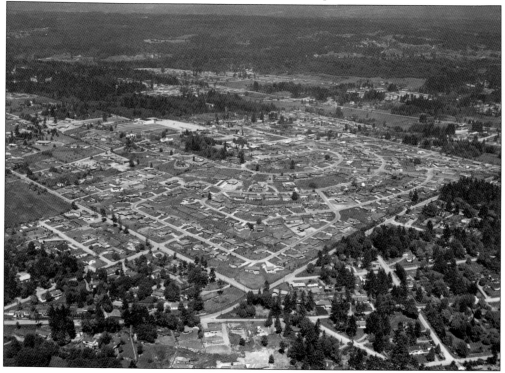

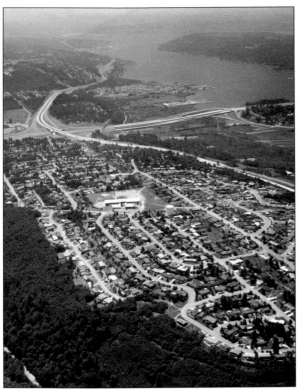

WOODRIDGE. While the massive developments to the east and south of Bellevue emphasized affordability and modestly sized homes, the Woodridge development just southeast of downtown Bellevue went more upscale. High on a hill between the Mercer Slough and the Kelsey Creek lowlands, it offered views to many residents and very convenient commutes. Both Woodridge and the adjacent Norwood Village community had swim clubs, and in 1958, the hill got a new elementary school to replace the original Factoria School. (Courtesy of the Washington State Archives.)

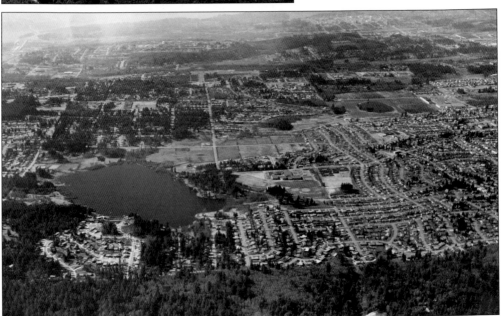

PHANTOM LAKE. Yes, there is a lake out there. In this view, looking west from over Lake Sammamish, Phantom Lake has become surrounded by the extended Lake Hills development. But the farmlands to the northwest of the lake, leading to the smaller Larsen Lake, remained undeveloped and now constitute the Lake Hills Greenbelt, one of the jewels of Bellevue's extensive park system. (Courtesy of the Washington State Archives.)

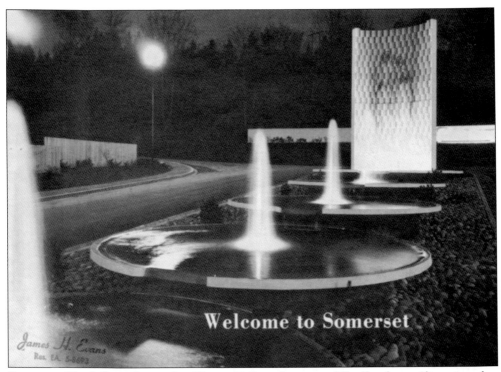

SOMERSET. The hills to the south of Route 10 (later Interstate 90) offered some fine views, but none as jaw-dropping as those from Somerset Hill. The entry monument, featuring the dramatic fountain shown on the cover of the sales brochure above, hints that this was not just another subdivision. The amazing views of Lake Washington, Mercer Island, Seattle, and on to the Olympic Mountains are unmatched on the Eastside and have made Somerset a prime residential area. Somerset Elementary School opened in 1972. The area's only downside was the extreme difficulty of negotiating the streets in snow and ice.

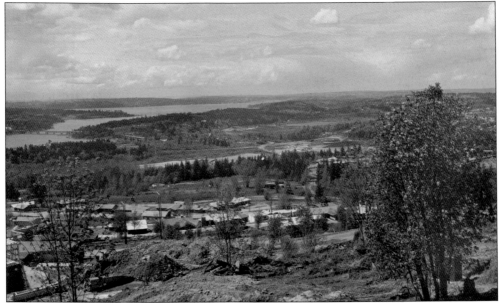

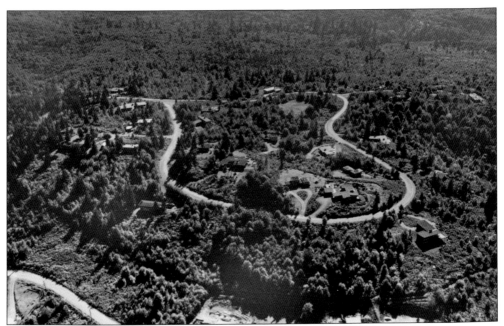

THE HILLTOP COMMUNITY. The vast, open spaces across Lake Washington did not just attract large commercial developers; they also attracted visionaries who hoped to build better places far from the city. In 1948, a group of 18 families headed across the bridge to look for a place to build a cooperative community that would feature modern architecture and planning methods. They settled on a tract south of Route 10, shown in the photograph above, that would accommodate 40 one-acre home sites plus substantial community-owned open space. The first home, shown below, was completed in 1950.

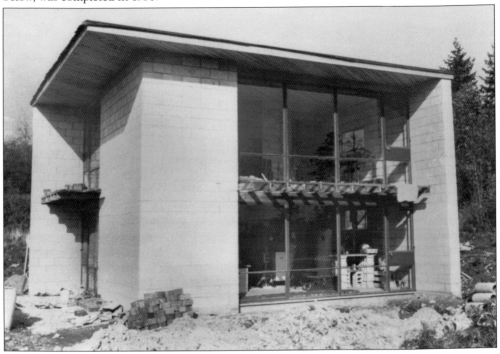

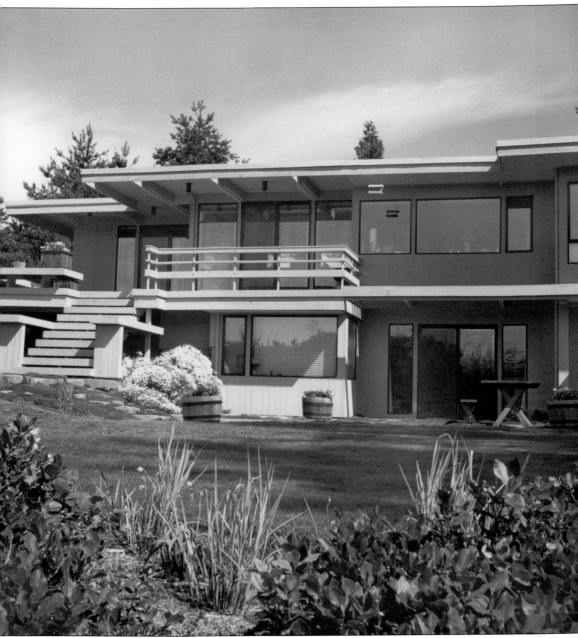

HILLTOP HOME NO. 33. Many of the founders of Hilltop were academics from the University of Washington, including faculty members from the schools of architecture, art, and music. According to one founder, all were "liberal, social-minded and civic-minded." They embraced the modernist architectural styles that were becoming common throughout the newly developing suburban areas. House No. 33, shown here, was completed in 1951.

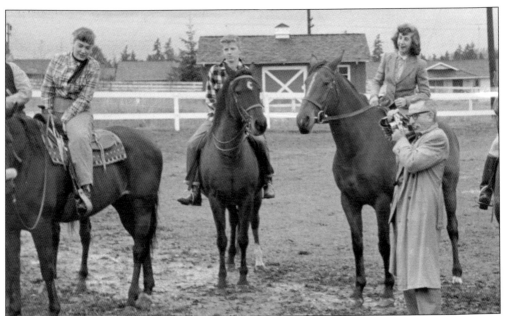

DIAMOND S RANCH. The horse-centered, Western lifestyle was a major cultural undercurrent in the 1950s and early 1960s, and developers provided opportunities to keep horses at home. One such development was the Diamond S Ranch, located to the north of downtown Bellevue. With its very large lots that could accommodate barns and with its shared riding track, Diamond S Ranch was a rural oasis in an area rapidly building out.

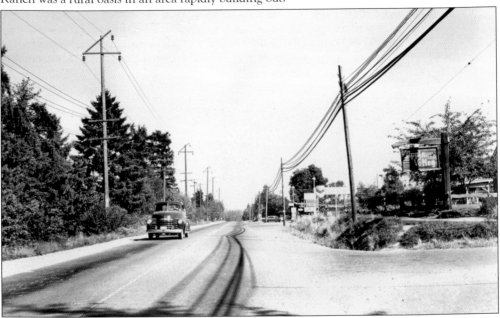

APPLE VALLEY. Just to the north of Diamond S Ranch and its well-to-do horsey set, Apple Valley offered modest homes in a cozy glen with easy access to Bellevue. The Northtowne shopping center provided conveniences, and when the SR-520 bridge was completed nearby, Apple Valley became a hidden gem. Many of the original homes have been replaced. (Courtesy of the Washington State Archives.)

NORWOOD VILLAGE. This planned residential community on the Woodridge Hill was among the earliest developments near Bellevue. The photograph above shows the Hook family home, completed in 1950. The photograph below, of the interior of a Norwood Village home, shows that the houses in these communities were not elaborate by today's standards. Residents were moving to a safe, quiet area with lots of families and a good school, and expectations for amenities in homes were limited. The contrast between these early suburban homes and what would become the norm by the 1980s is quite striking.

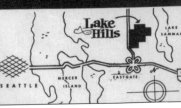

A MODEL COMMUNITY. Young families in the 1950s were eager to put the miseries of the Depression and war eras behind them, and for many, that meant leaving behind the tired, old cities and heading out to the new communities where everything was modern, clean, and shiny. Bellevue offered many opportunities for exactly that kind of lifestyle shift. But a close reading of this sales brochure for Lake Hills shows just how modest the expectations were. "No septic tanks are allowed in Lake Hills . . . sewers are in!" Suburban living in the 1950s was not about luxury, but about modernity, the casting off of the accretions of old societies that dominated big cities. Oddly enough, American suburbs became a realization of the visions of the original European modernists who saw an egalitarian, working- and middle-class society living without unnecessary frills. That same vision brought tens of thousands of families to Bellevue in search of "modern, convenient living!"

Five

SHOPPING

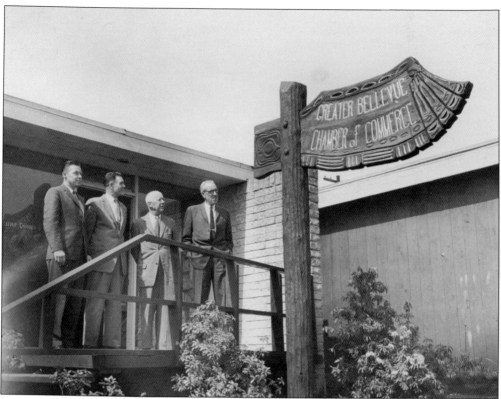

BELLEVUE MEANS BUSINESS. Long before Bellevue became a major employment center, it had an aggressive business community that meant to take full advantage of the opportunities presented by rapid residential growth on the Eastside. Even though most of the new homes were being built outside of the original Bellevue core, no other commercial center would rival downtown Bellevue for providing goods and services to the territory between Renton and Kirkland. The Bellevue Chamber of Commerce, whose officials are shown here, promoted retail and professional services in the downtown core and did everything possible to keep residents from crossing the bridge to meet their needs.

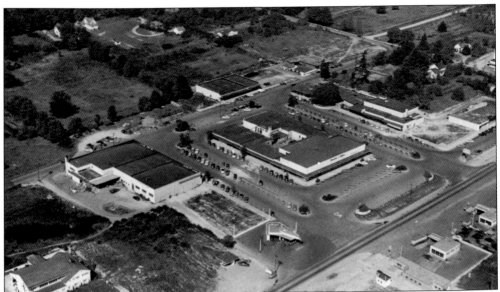

EARLY DAYS AT BELLEVUE SQUARE. As World War II drew to a close, businessmen in Bellevue had ambitions that would stretch far beyond the old commercial center of Main Street. The biggest realization of those visions would be the Bellevue Square shopping center. Kemper Freeman Sr. had envisioned the project and had begun to acquire property for it in the late 1930s, but he had to wait until the end of the wartime restrictions on building materials to get started. He began with the Bel-Vue Theater, which was seen as an amenity for Houghton shipyard workers, but scored his first major coup by recruiting an Eastside branch of Seattle's Frederick & Nelson department store, shown in the center of the photograph above. Soon, other retailers signed up, and he had several buildings constructed and leased. By the mid-1950s, as seen below, the center had acquired a new, larger Frederick & Nelson store and the west parking area, but the surroundings remained mostly unbuilt.

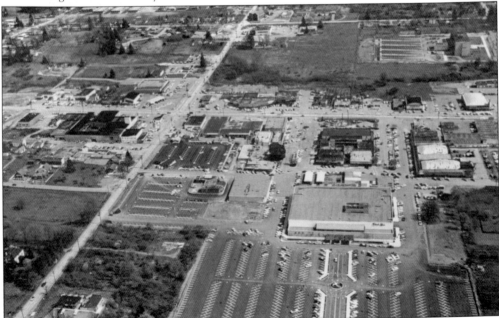

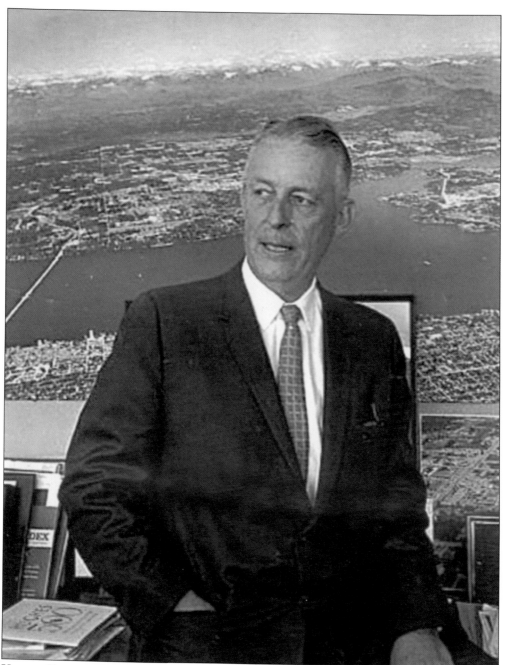

KEMPER FREEMAN SR. The son of publisher and maritime booster Miller Freeman, Kemper Freeman Sr. began to think about the opportunities in Bellevue in the late 1930s. The area had been growing, but there was little in the way of retail and entertainment. Recognizing that the automobile was transforming the nature of retailing, Kemper and his daughter took a long road trip to examine new shopping centers around the country. He found his model in the Highland Park Shopping Center outside Dallas, and with financing and help from his father and brother, set about creating what remains the center of Bellevue retailing. (Courtesy of the Seattle Post-Intelligencer Collection, Museum of History and Industry.)

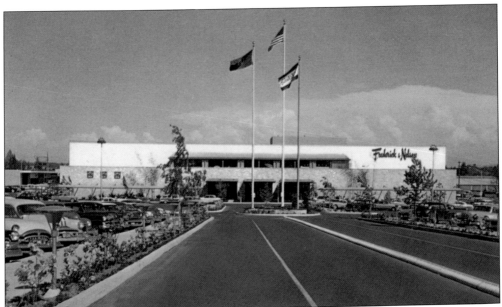

EXPANDED FREDERICK & NELSON STORE. The Frederick & Nelson division of Marshall Fields had such success with the original Bellevue store that they committed to a much larger store that would form the anchor of an expanded shopping center. The new store, facing the rest of the center on the east and a massive parking lot and grand entry on the west, opened in 1956.

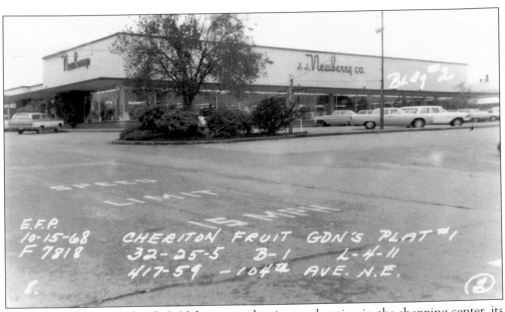

NEWBERRY'S. When Frederick & Nelson moved to its new location in the shopping center, its original space was taken over by a branch of the J.J. Newberry variety store. That store subsequently closed, and the prime space in the middle of the shopping center, facing Bellevue Way, was converted to smaller shops. (Courtesy of the Washington State Archives.)

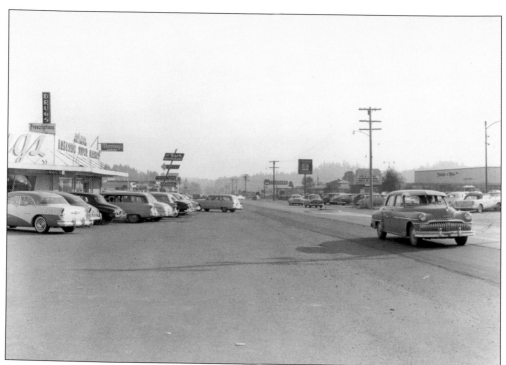

AUTOMOBILES RULE. Bellevue Square had taken shape during an era when the automobile was king. Although one of the first examples of a pedestrian-oriented mall—Northgate—was in the region, Bellevue Square was clearly designed around the idea that shoppers wanted to drive as close as possible to their destination. In this photograph, taken for a 1955 study of how to improve 104th Avenue, Bellevue Square is on the right. (Courtesy of the Washington State Archives.)

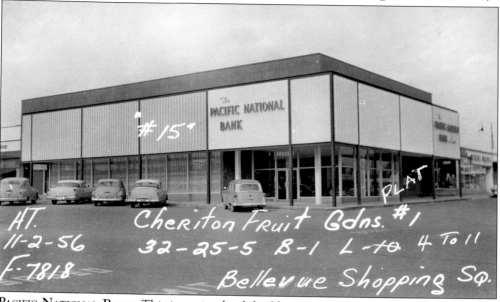

PACIFIC NATIONAL BANK. This imposing bank building occupied the most prominent corner of Bellevue Square, right at the main entrance off Bellevue Way. (Courtesy of the Washington State Archives.)

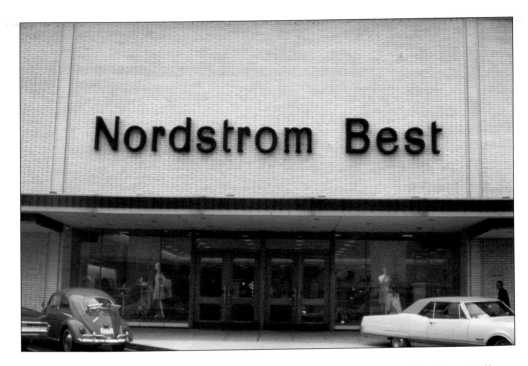

NORDSTROM BEST. For two decades, Frederick & Nelson was the unquestioned anchor of Bellevue Square. Then, in 1967, Nordstrom Best opened a large store just to the north of Frederick & Nelson. The photograph below shows the grand reopening of Nordstom in 1982. Both the Frederick & Nelson and Nordstrom buildings were retained intact as the new, enclosed mall was built in the early 1980s, and their bones remain under the west section of the mall.

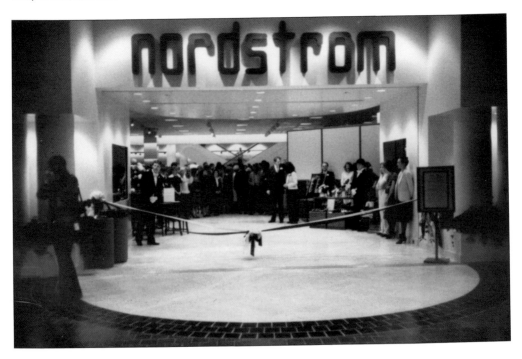

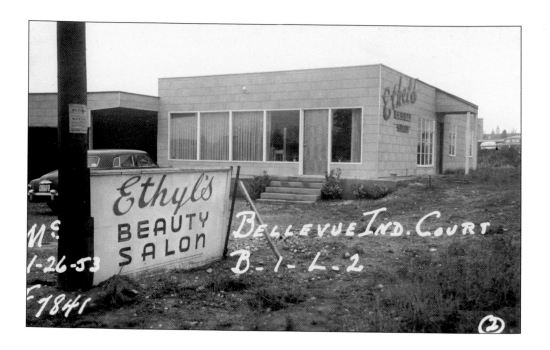

NOT ALL GLAMOUR. While Bellevue Square was creating a certain degree of sophistication with its art shows, tearoom, and lunches at the Crabapple Restaurant, other parts of downtown Bellevue were not quite so chic. These two long-forgotten retailers were in the Bellevue Industrial Court, between 104th and 106th Avenues, south of Northeast Fourth Street. In the early 1950s, when these photographs were taken, land was still inexpensive, and an entrepreneur could put up a low-priced building and make a go of it. This particular section of Bellevue remained a light industrial area for many years and still has some home-improvement stores. (Both, courtesy of the Washington State Archives.)

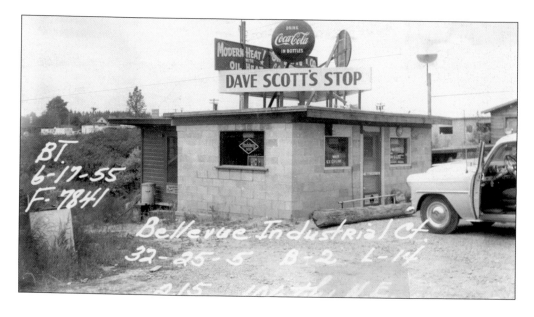

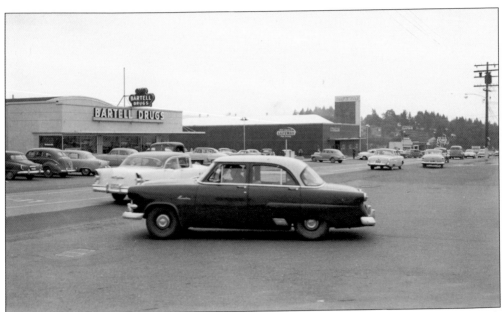

SAFEWAY AND BARTELL'S. These two prominent retail chains, one national and the other regional, moved into Bellevue in the early 1950s, with Safeway opening it store on 104th Avenue across from Bellevue Square in 1952. The photograph above shows both stores built up against 104th Avenue while it was still a two-lane street (Safeway is the dark building in the center). In 1962, Safeway opened a new store in its well-known arched-roof design, well back from the street, with the parking lot out front. That store closed in 2007, and the property will become a residential and commercial development. Safeway is now in its third location in downtown Bellevue, one block to the south. (Above, courtesy of the Washington State Archives; below, courtesy of Eastside History Center.)

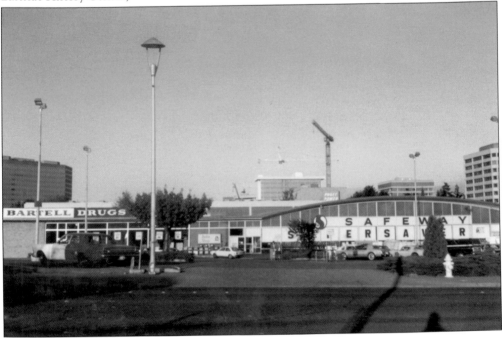

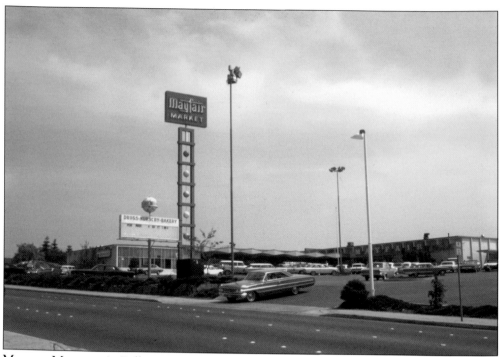

MAYFAIR MARKET. As Bellevue expanded, grocery retailing moved up the hill to 108th Avenue. The large shopping center at the corner of 108th Avenue and Main Street featured the Mayfair supermarket. This center is still in operation, with Office Depot occupying the Mayfair space.

UNCLE HAROLD'S. Shopping centers are not usually designed with boys in mind, but Bellevue Square had one destination for them. Uncle Harold's, shown in the center of this photograph, was a bike shop, hobby shop, model shop, and general purveyor of things for young men. (Courtesy of the Washington State Archives.)

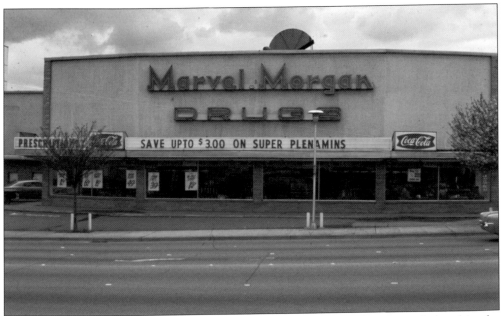

MARVEL MORGAN DRUG STORE. Marvel Morgan, a Rexall Drug Store, was located in the Homemakers Center at 857 Bellevue Way Northeast and had prominent signage and a loyal clientele. A popular shopping destination in the 1960s, it was among the few places in Bellevue to find hard ice cream. Their Yellow Pages advertisement of March 1963 boasted of a complete camera shop, low prices, and long hours.

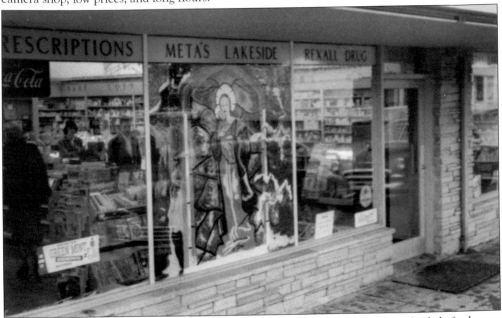

META BURROWS AND LAKESIDE DRUGS. While much of the retailing action had shifted away from old Main Street in the 1950s and 1960s, Meta Burrows's original Lakeside Drugs held on. Burrows was a member of one of Bellevue's pioneer families and was one of the community's most prominent and active business owners. Her drugstore and lunch counter were fixtures in the community, closing in 1979 when she retired.

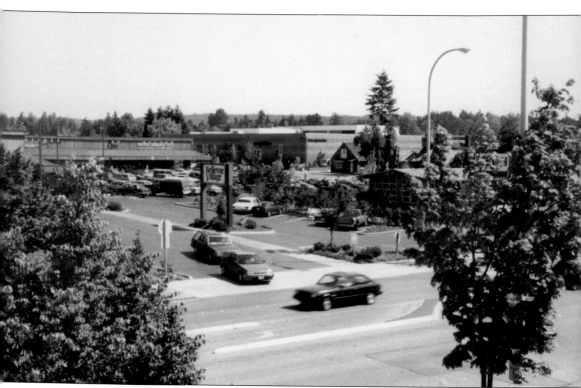

BELLEVUE VILLAGE. Just to the north of Bellevue Square, the Fortin family built the Bellevue Village shopping center in the mid-1960s. Vern Fortin was a founder of the Quality Food Centers (QFC) grocery chain, and one of the early stores was built on the site and remains there along with the chain's administrative headquarters.

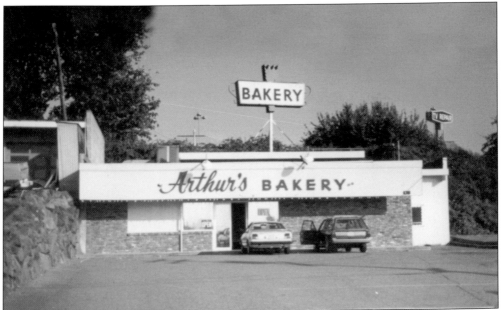

ARTHUR'S BAKERY. Arthur's Bakery was located on 107th Avenue behind Pay 'N Save. The beloved bakery endured for 38 years, opening in 1956 and closing in 1994. Arthur's supplied blueberry pies to the Blueberry Festival from 1957 to 1959 and, as part of the opening-day festivities for the renovated Bellevue Square, baked the "biggest cake ever in Bellevue."

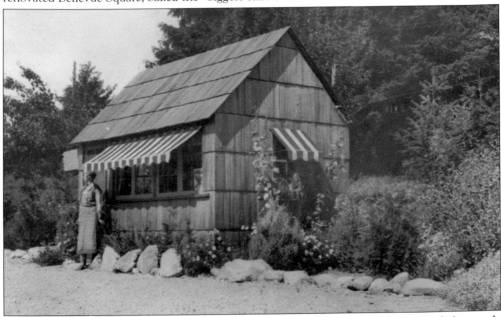

THE KANDY COTTAGE. During the 1930s, Bellevue resident Mina Schafer entered the candy business. Her husband, Louis, built the cottage shop, which she named for her mother, Jenny (Jane) McDowell. The shop was connected to the house by a bell system so that when a customer entered, Mina could run down to wait on him or her. The two candy makers capitalized on the "round-the-lake" traffic of Seattle residents having a day's outing to the "country." (From the Eminson Schafer collection.)

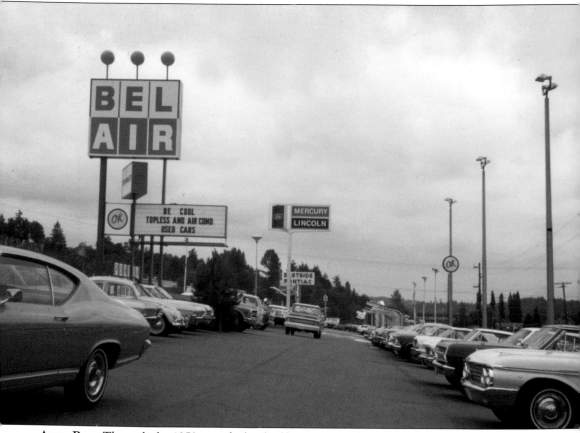

Auto Row. Through the 1950s, car dealers had been scattered around the downtown area, along 104th Avenue, and along Northeast Eighth Street. Then, beginning in the 1960s, dealers moved to new, larger properties along 116th Avenue, between Main Street and Northeast Eighth Street. Auto Row gave dealers much more space to display inventory and gave customers access to a wide range of makes and models.

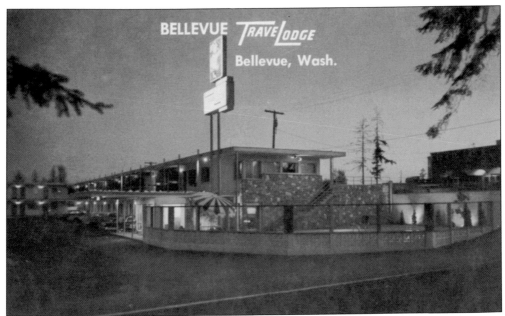

ROOM AT THE INN. As it attracted the amenities of a growing city, Bellevue lacked one important feature: hotels. These two photographs show the kinds of properties that visitors could look forward to. The Travel Lodge was located on Northeast Eighth Street at 110th Street. The independently owned Eastgate Motel offered travelers on Route 10 a resting spot. But neither these nor the Bellevue Motel (located north of downtown) were four-star accommodations; that would have to wait a few decades.

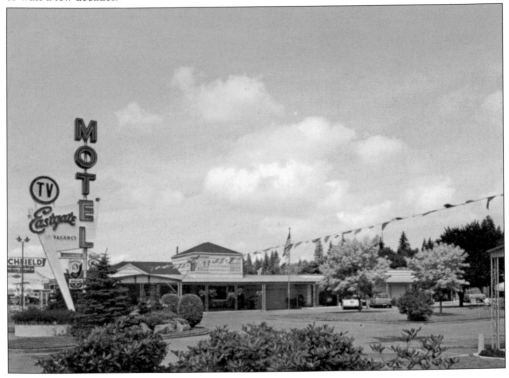

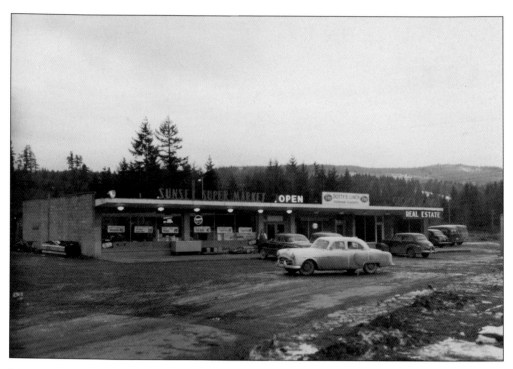

NEIGHBORHOOD SHOPPING. As Bellevue grew out from its traditional center, developers added neighborhood shopping centers to meet local needs. The photograph above shows a small shopping center at Factoria in 1955. The image below shows the Northtowne shopping center north of downtown Bellevue, near Apple Valley.

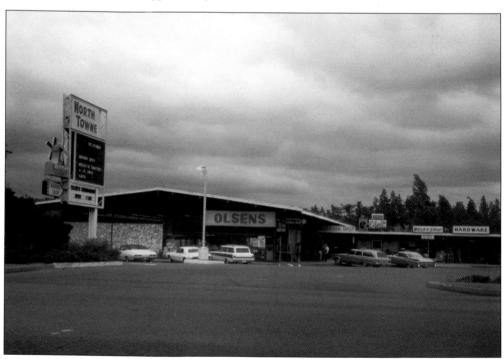

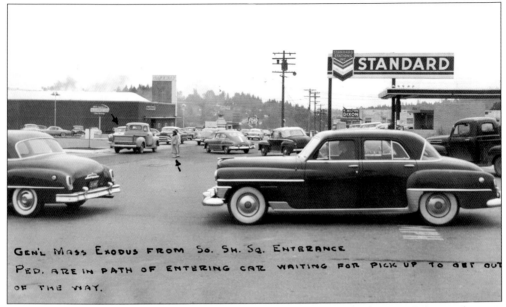

GEN'L MASS EXODUS FROM So. SH. Sq. ENTRANCE
PED. ARE IN PATH OF ENTERING CAR WAITING FOR PICK UP TO GET OUT
OF THE WAY.

CARS, CARS, CARS. It is cliché to describe suburbs as being totally built around the car, but it is largely true. Bellevue's early commercial developments on Main Street depended on customers in cars, and all developments since have assumed that nearly all customers would arrive in a car and need a convenient place to park. Hence the massive parking lots and garages at Bellevue Square, shown above in 1955, and at Crossroads, shown below in the early 1960s. (Above, courtesy of the Washington State Archives; below, courtesy of the *Seattle Times*.)

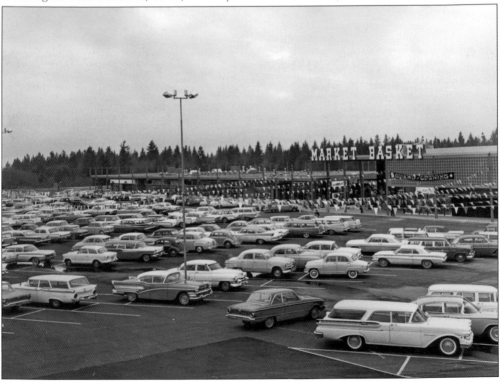

Six

HAVING FUN

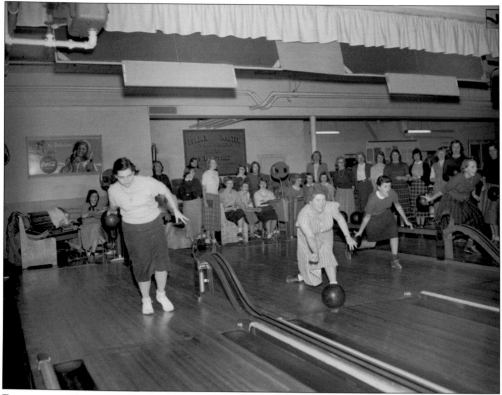

BOWLING IN BELLEVUE. In the mid-1940s, Bellevue had very few places to go and things to do. In fact, the Bel-Vue Theater was begun during the war, when little else got built, to provide something for war workers in Houghton to do. Aside from some scattered school playgrounds, the area had little in the way of public parks, entertainment, or even nice restaurants. That would change dramatically over the next two decades as local governments and entrepreneurs combined to make Bellevue a much livelier place. Those investments included Bellevue Bowling and Recreation, which was located beneath Ernst Hardware, where these girls from the Bellevue High School girls' athletic club aimed for strikes.

play courts

little league playfield

professional tennis courts

$200,000 Recreation and park center featuring Olympic-size heated swimming pool

One of the most attractive features to potential home buyers is Newport Hill's unique recreation and park facility which provides an abundance of wholesome living for the exclusive enjoyment of Newport Hills families.

STARTING FROM SCRATCH. The lack of parks and recreational amenities was an immediate problem for the large new subdivisions built near Bellevue in the 1950s. These developments were still in unincorporated King County, and county government had little capacity to build new facilities. That meant that the developers themselves had to provide parks, ball fields, pools, and tennis courts, like those described here for Newport Hills.

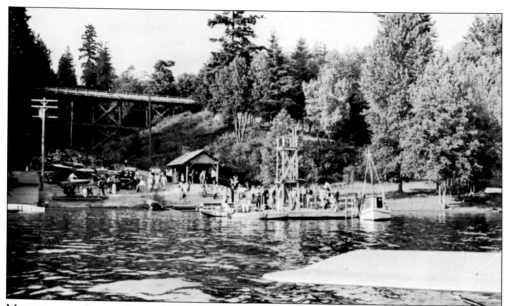

MEYDENBAUER BEACH PARK. A beach created in a ravine leading to the shores of Meydenbauer Bay, this one of the first properties in Bellevue's park system. It was a popular swimming and picnic destination, and the Bellevue Parks Department offered summer swim lessons. Since then, Bellevue has built a large and renowned park network, including several beaches. Farsighted action by the city preserved some of the remaining farmlands, including those in the Mercer Slough and the Larsen Lake area, as well as the former dairy farm at Kelsey Creek. (Above, from the collection of the Eastside Heritage Center; below, courtesy of the Washington State Archives.)

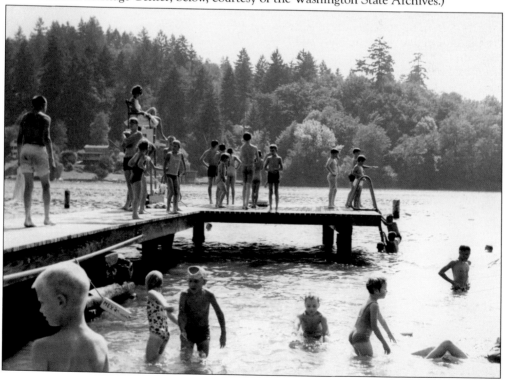

Soccer Comes to Bellevue. In the 1950s and 1960s, soccer was still an unfamiliar and exotic sport for most of the country. The game became popular in the Seattle area—the Eastside in particular—as the Boeing Company hired legions of engineers from England, Scotland, and Ireland who wanted opportunities for their children to learn their own national pastime and took up the coaching duties. A feature of the soccer program at the Bellevue Boys' Club was an exchange with teams from Canada. This photograph shows a game between the Medina Tigers and the Vancouver Highriggers. (Courtesy of the Washington State Archives.)

TENNIS, ANYONE? Tennis was a popular sport in Bellevue, with developers building tennis courts into their recreation centers. In the photograph above, Glen Young, an instructor with the Bellevue Parks and Recreation Department, teaches the game to John Greswald and Greg Elliot. Tennis facilities began to flourish in the 1960s, with the Bellevue Racquet Club at the corner of Bel-Red Road and 140th Avenue, the Supersonics Racquet Club near Bridle Trails, the Robinswood Tennis Center (shown below). (Above, courtesy of the Washington State Archives; below, from the collection of Eastside Heritage Center.)

BELLEVUE HIGH SCHOOL SKI CLUB. By the 1950s, the ski areas of Washington were well established, and with Bellevue just 45 minutes from the slopes of Snoqualmie Pass, skiing was a very popular sport. The photograph above shows members of the Bellevue High School Ski Club at Snoqualmie Summit during the 1954–1955 season.

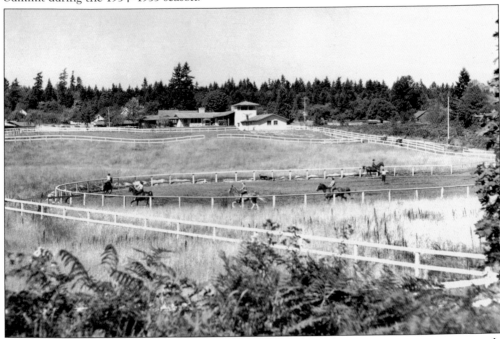

HORSEBACK RIDING. For those who could afford it, Bellevue offered many opportunities to ride horses. Diamond S Ranch, just north of downtown Bellevue, provided homesites that could accommodate barns and horses. Just to the east, Bridle Trails State Park became ringed with housing developments that included enough space for horses.

BELLEVUE ICE PLAZA.
Few long-gone institutions of mid-century Bellevue evoke as much nostalgia as the Bellevue Ice Plaza, which stood on 112th Avenue. It hosted figure skating and hockey and was the site of thousands of birthday parties. And Bellevue, which has no permanent ice rinks today, even had a second rink, at Crossroads. Both became victims of rising costs, changing tastes, and in the case of the Bellevue Ice Plaza, demand for commercial real estate near Interstate 405. (Above, from the collection of Eastside Heritage Center; below, courtesy of the Washington State Archives.)

Bellevue Ice Plaza

**330 - 112 AVENUE N.E.
BELLEVUE, WASHINGTON
GLencourt 4-1460**

BEAUTIFUL - SCENIC - OPEN AIR
(protected from weather)
Public, Patch and Private Sessions

Hockey

5 minutes from downtown Seattle

Special rates to scout, school, church and youth groups

Top Professional Teaching Staff

Home of
Overlake Skating Club Overlake Curling Club

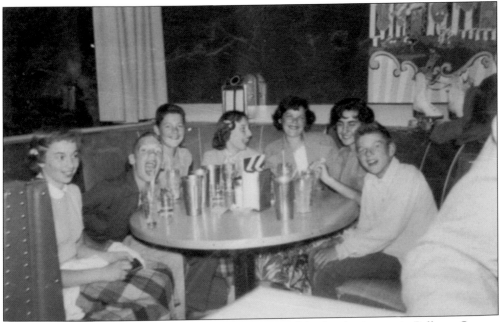

THE KANDY KANE. The Kandy Kane soda fountain, one of the first businesses in Bellevue Square, stood next to the Bel-Vue Theater. As seen in this photograph from 1951, it was the favorite hangout for the younger set.

FARRELL'S. With the Kandy Kane long gone, Bellevue needed a new place to meet its ice-cream needs. Farrell's old-time ice-cream–parlor chain opened a branch in the Bellevue Village shopping center and was an immediate hit, serving sundaes, "Mount Rainiers," and "pig's troughs" until franchises began closing in the 1980s.

MCDONALD'S ON 104TH AVENUE. The original "Golden Arches" arrived in Bellevue, on the corner of 104th Avenue and Northeast Second Street, in 1969.

WF
12-9-65
F 7790
2.

TL. 272
1004 - 104th Ave. N.E.

29-25-5

DICK'S DRIVE-IN. Yes, Bellevue at one time had a location of the legendary Dick's Drive-In at the corner of 104th Avenue and Northeast Tenth Street. It opened in 1965 and competed with another local chain, Herfy's, across the street. Dick's closed in 1973, and efforts to get the chain back to the Eastside have never been successful. (Courtesy of the Washington State Archives.)

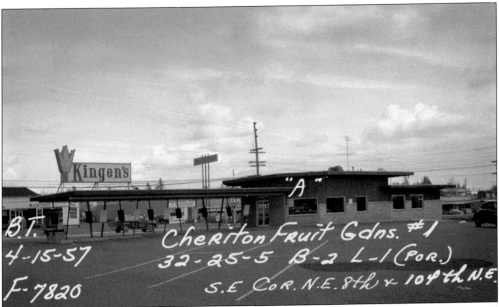

KINGEN'S DRIVE-IN. On the prominent southeast corner of the intersection of 104th Avenue and Northeast Eighth Street, this drive-in went by several names, including the Carnival and Tommy's Den. It is best remembered as Kingen's, owned by the same restaurant family that went on to found the Red Robin chain and now owns Salty's. (Courtesy of the Washington State Archives.)

DAIRY QUEEN. Way out on the edge of downtown, near Interstate 405, was the fast-food outpost of Dairy Queen. It became the favorite stopping place for youth sports teams after games and anyone in the area in need of a fast sweet treat. Opened in 1961, it lasted until the Bravern complex broke ground in 2006. (Courtesy of the Washington State Archives.)

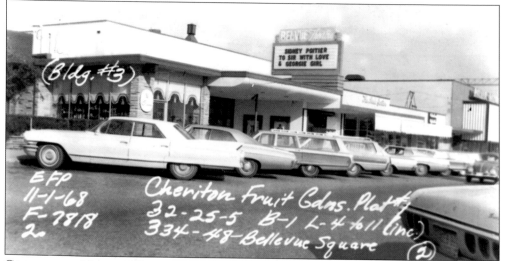

In the photo, handwritten annotations read:

(Bldg. #3)

E FP
11-1-68
F-7818
2o

Cheriton Fruit Gdns. Plat #
32-25-5 B-1 L-4 to11 Inc.
334-48-Bellevue Square

GOING TO THE MOVIES IN BELLEVUE. Prior to 1946, even during the golden age of movies, Bellevue had no place to watch one. Then, recognizing that the workers who had moved to the Bellevue area to work in the Houghton shipyard and Seattle and Renton airplane factories during World War II had little local entertainment, the federal government provided scarce materials to construct the Bel-Vue Theater, an elegant space in the new Bellevue Square. As the city grew and the big epics of the time needed larger screens, the Bellevue-based Sterling Recreation Organization built its flagship John Danz Theatre on 106th Avenue. Patrons were greeted by a stained-glass picture of a pirate as they entered the 1,500-seat theater to see all the first-run movies of the time. Unable to compete with the multiplexes, the John Danz showed its last feature, *Forrest Gump*, in 1994. (Above, courtesy of the Washington State Archives; below, from the collection of the Eastside Heritage Center.)

THE VILLAGE INN. Just to the north of Bellevue Square, the Village Inn's roadside sign advertised "fine food," offering a menu of burgers and sandwiches. Of note was the Village Inn Salad Delight, consisting of "delicious fruit salad topped with soft ice cream and served with buttered toast."

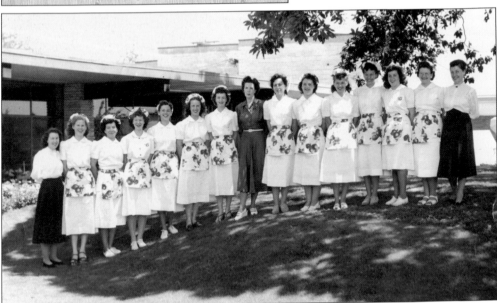

THE CRABAPPLE RESTAURANT. Drive-ins and ice-cream parlors spring up easily in a fast-growing, family-oriented community, but fine dining takes more effort. In 1946, Carl Pefley, former chef at the Washington Athletic Club, opened the Crabapple Restaurant in the new Bellevue Square. It featured a local-arts theme, which became the root of the Pacific Northwest Arts and Crafts Fair. The Crabapple developed into a hub of Bellevue social life and was later taken over by the Clark family, which operated several Seattle-area restaurants.

THE PLAYBARN. The Surrey Playbarn opened on June 15, 1948, with the play *Night Must Fall*. It operated from a barn on the former R.T. Reid fruit and flower farm in what is now the Surrey Downs neighborhood. It later moved to Crossroads Mall, and its final location was in the old Japanese clubhouse. The Playbarn offered children's theater programming from 1967 until 1977, including the production of *The Reluctant Dragon* shown at right.

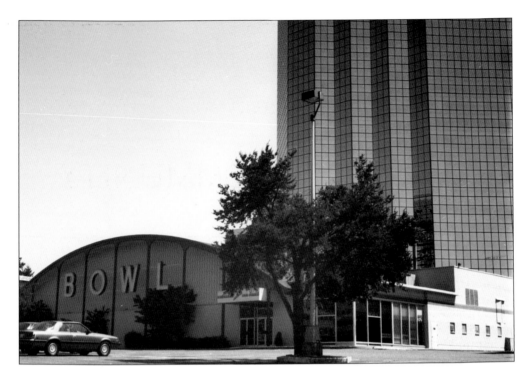

Downtown Activities Give Way. When downtown Bellevue was just developing, it could support a diverse range of activities. But as it became a larger commercial area and employment center, something had to give. The Bellevue Lanes bowling alley, shown above, became more valuable as commercial space, and it now houses a large and popular Barnes & Noble bookstore. The Olympic Pool, which was located off 106th Avenue near Northeast Second Street, gave way to new commercial development in the 1970s. (Above, from the collection of Eastside Heritage Center; below, courtesy of the Washington State Archives.)

Seven

BUILDING COMMUNITY

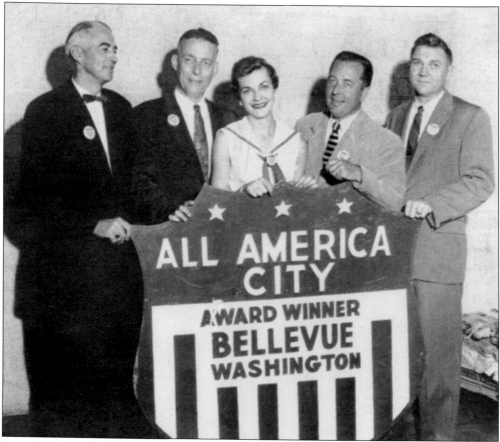

ALL AMERICA CITY, BELLEVUE'S COMING-OUT PARTY. In a fast-growing suburb, a sense of community can take a long time to evolve, but Bellevue was in a hurry. In 1955, just two years after incorporating, Bellevue was named one of *Look Magazine*'s All America Cities. The effort, organized by the Bellevue Chamber of Commerce, resulted in welcome publicity for the new city, but it also signaled the kind of proactive energy that would make Bellevue more than just another suburb. Intentionality matters, and Bellevue always had plenty of it as leaders built infrastructure, institutions, and a strong sense of place. If pride and hustle are all-American traits, then the judges at *Look* and the National Municipal League picked the right city that year.

THE BELLEVUE COMMUNITY CLUB. For the first 50 years of its history, social life in Bellevue centered on the Bellevue Community Club and its clubhouse on 100th Avenue, just up from Main Street. As the city matured, the clubhouse lost its central role, and it later became the Bellevue Boys Club. The Bellevue Boys & Girls Club still occupies the site.

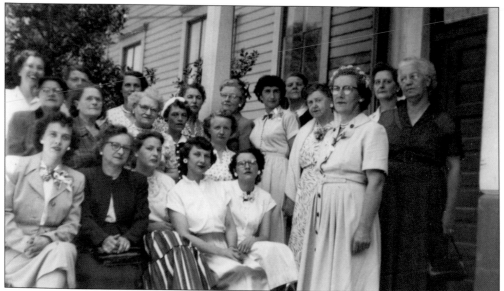

VETERANS OF FOREIGN WARS BELLEVUE CHAPTER. Bellevue had just a few veterans of World War I, but by the end of World War II, it had a long list of potential members for the Veterans of Foreign Wars (VFW). The Bellevue chapter took over the original Bellevue school on the corner of Main Street and 100th Avenue. The building would later become Bellevue's first city hall. This photograph shows a 1954 gathering of past presidents of Bellevue's VFW Auxiliary Post No. 2995.

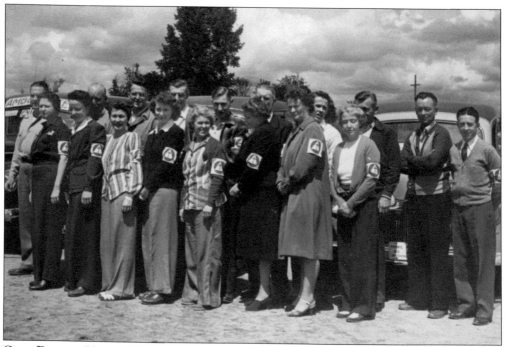

CIVIL DEFENSE VOLUNTEER FIRST AID UNIT. As it did across the country, World War II brought citizens of Bellevue together. Shown here is a civil defense unit in 1942.

ALL AMERICA CITY. The judges of the All America City Award did not focus on beauty or boosterism. They sought to recognize excellence in planning, infrastructure, and all the mundane things that go into making a city work, especially a fast-growing one. The recognition meant that businesses looking for a place to invest or families looking for a place to move would see Bellevue as a city with its act together. In this photograph taken at the Crabapple Restaurant, local leaders assemble to celebrate. From left to right are Robert Reid, chamber president; Al Thompson, school board president; Pete Dailey from *Look Magazine*; Ben Lewis from Riverside, California (another winner); and Bellevue mayor Melvin Love.

PARADES. The All America City Award not only provided an excuse for a parade in downtown Bellevue, it sent Bellevue representatives to other parades. The photograph above shows the float created to represent Bellevue in regional parades. Below, Bellevue beauty Jerrie Lee Kelso is paraded through Pasadena in the 1957 Tournament of Roses parade. Riverside, California, one of the cowinners of the All America City Award, arranged for young ladies from each of the 11 winning cities to be in the parade.

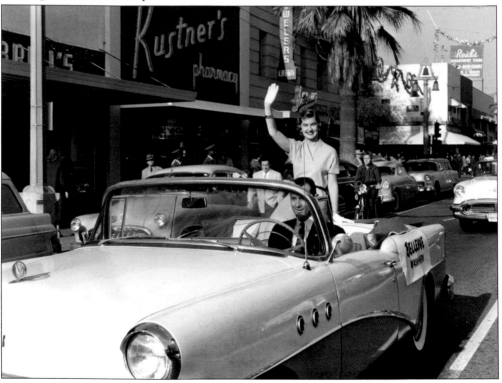

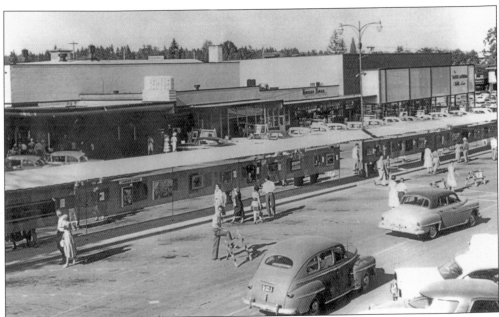

Pacific Northwest Arts and Crafts Fair. When he opened the Crabapple Restaurant in 1946, Carl Pefley invited local artists to hang paintings on the walls. What he did not bank on was becoming an art dealer, as patrons asked to purchase the paintings on display. That gave Pefley the idea to sponsor an art fair once a year. It was an immediate success, and the Pacific Northwest Arts and Crafts Association was incorporated the following year.

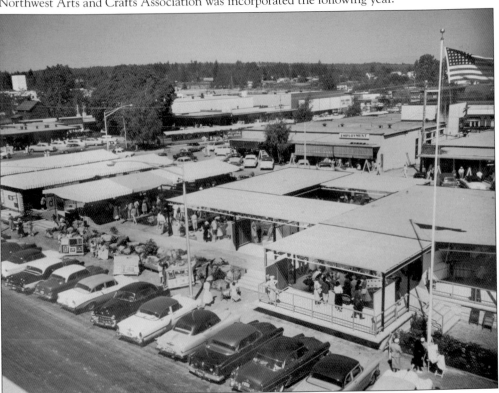

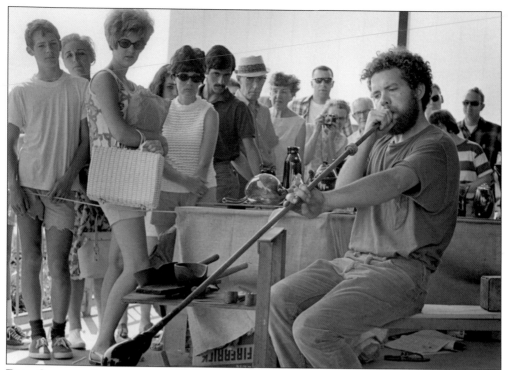

DALE CHIHULY. An attraction of the Pacific Northwest Arts and Crafts Fair was its emphasis on demonstrations and handcrafts. Here, a very young Dale Chihuly demonstrates glassblowing in 1968. (Courtesy of the Seattle Post-Intelligencer collection, Museum of History and Industry.)

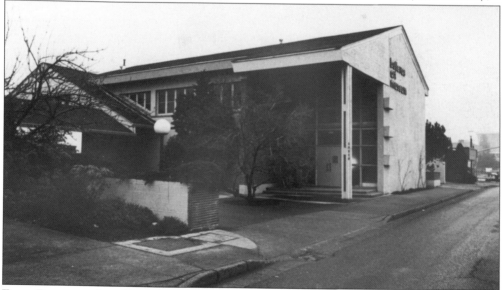

FIRST BELLEVUE ART MUSEUM. As Bellevue gained a reputation as an arts center, it needed a museum for a year-round presence. The Bellevue Art Museum opened its doors in 1975 in a former funeral parlor—Green's Chapel of Flowers—on Northeast Fourth Street, on the south edge of Bellevue Square. The museum later moved to the third floor of the new mall, and later to its own building on Bellevue Way.

HOME OF BOEING BRASS. Bellevue and the Points Communities were popular neighborhoods for the men and women busy building the Boeing Company into a world industrial power. One of the most visible of these was Tex Johnston. The flamboyant Texas-born test pilot famously barrel-rolled a 707 prototype over the Lake Washington hydroplane racecourse in 1955, cementing his place in local business lore. (Courtesy of Gary Johnston.)

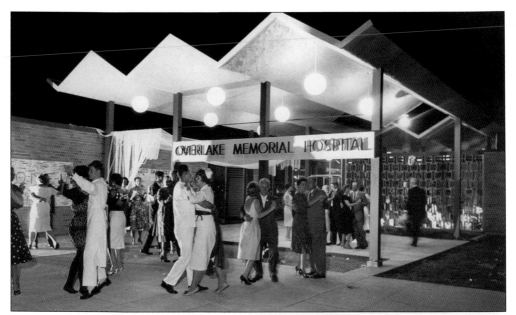

BUILDING OVERLAKE HOSPITAL.
As Bellevue and the larger
Eastside grew, so did the need
for healthcare services. The
big hospitals of Seattle were
a long way off, especially in
an emergency, so civic leaders
got together to build Overlake
Hospital. Unlike hospital
districts formed in other
communities, Overlake remained
an independent nonprofit and
thus needed to raise money. The
photograph above, from 1960, is
of the first Bandage Ball, which
is now the hospital's annual
fundraising event. Pictured at
right in 1981, hospital officials
ride in a hot-air balloon to
cut the ribbon on Overlake
Hospital's new addition. Shown
from left to right are Robert
Rabideau, executive vice
president of the hospital; Gene
Lynn, with Careage Corp; and
Wayne Hodnett, recruiter for
the Air National Guard and
driver of the balloon. (Above,
courtesy of the Overlake
Hospital Foundation; below,
ourtesy of Museum of History
and Industry.)

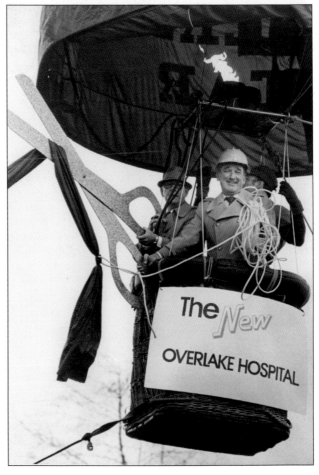

BUILDING FAITH COMMUNITIES.
As Americans settled new
lands, churches were among the
first institutions established in
any community. Bellevue had
churches for most denominations,
but as the area grew, these small
churches could not keep pace
with expanding congregations. In
the photograph at left, Elizabeth
Park, of Medina, and Thomas
Luis, of Honolulu, exchange vows
in the old Sacred Heart Church
on Main Street in 1956 with the
redoubtable Fr. Gerald Moore
presiding. A new, very large
Sacred Heart Church opened
on Clyde Hill in 1958. Below is
the original white church of the
Christian Science congregation
near Meydenbauer Bay, which
was later replaced by the much
larger church now on the site.
(Left, courtesy of Elizabeth Park
Luis; below, courtesy of Bellevue
Christian Science Church.)

BELLEVUE CONGREGATIONAL CHURCH. Occupying the most prominent church site in Bellevue, the Congregational Church at 108th Avenue and Northeast Eighth Street has served the downtown community since 1896. The original structure, shown above, was replaced by the current building, shown below, in 1958. The last operating church in downtown Bellevue, it faces an uncertain future as property values soar.

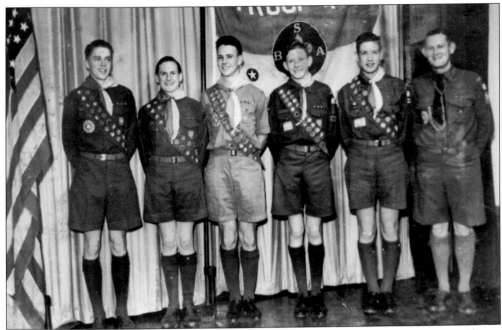

BOY SCOUTS. Scouting was very active in the Bellevue area during the 1950s and 1960s. Shown here are scouts from the Hunts Point-Yarrow Point area. They are, from left to right, Jack Barron, Bob Cahill, Dick Klosfer, Bob Lee, and Bill Stevenson. On their far right is their scoutmaster, Einar Fretheim, the principal at Bay School.

BELLEVUE'S NEW LIBRARY. Every community needs a library, and Bellevue had several. In 1961, the library moved into the old Sacred Heart Catholic church on Main Street after the parish had moved into its much larger church on Clyde Hill. Then, in 1967, the library moved into its lovely new home next to city hall, as seen on the right in this photograph. After the library moved to its current home on the old Ashwood School property in 1993, the previous library building became headquarters for the Bellevue Police Department.

OVERLAKE SERVICE LEAGUE. In 1911, a group of women established Overlake Service League (OSL), branching out from the Seattle Fruit and Flower Mission. Membership circles were formed by neighborhood, with each club working under the ethos that "the needs of our own immediate community are so urgent that we feel it necessary to devote our help to this, our own locality." OSL is now called Bellevue LifeSpring. This photograph shows 1952 Overlake Service League Executive Board members, from left to right, Harriet Constans, Betty Kimsey, Eleanor Loper, Rutheda Brown, and Margaret Ryan.

YOUTH EASTSIDE SERVICES. Established in 1968 and housed in the old Kandy Kottage building, Youth Eastside Services (YES) was formed by a group of volunteers who were concerned about the increase in drug use amongst teenagers in the 1960s. YES provided drop-in counseling services, where teens could "rap" with adult volunteers. Today, YES is still helping young people and their families deal with emotional issues, drug and alcohol abuse, and violence. In this photograph, early Rap Session volunteers are relaxing at the office. (Courtesy of Bob Hasson, YES.)

MUSCLE BEACH WITH NORM BLYE. The muscle-beach craze of the 1950s did not miss Bellevue. Longtime resident and Lake Washington Ferry expert Norm Blye was a bodybuilder and acrobat. He is pictured here at the top of the formation with his partners. (Courtesy of Ester Blye.)

THE ROBINSON FAMILY. In 1934, Naomi and Roger Robinson moved to Bellevue. Although the Eastside had long had many Asian American families among its residents, the Robinsons were among the few African American families in the area. Naomi worked for the Bellevue School District and as one of the head teachers for Seattle's Head Start program. (Courtesy of Tina Robinson.)

DIANA SCHAFER, MISS WASHINGTON 1957. Bellevue native Diana Schafer became Miss Washington in 1957 and is shown here representing the state at the Miss Universe Pageant in Long Beach, California. Schafer was a sophomore drama major at the University of Washington at the time and was also an experienced model. (Courtesy of Diana Schafer Ford.)

HALLOWEEN AT THE RONDYVOO TAVERN. While Bellevue had the art-themed Crabapple and the elegant Frederick & Nelson Tearoom, it also had its share of watering holes. The Rondyvoo Tavern stood just south of the corner of Main Street and 104th Avenue in a prime spot to capture the commuters returning over the Mercer Island bridge.

Eight

GOVERNING

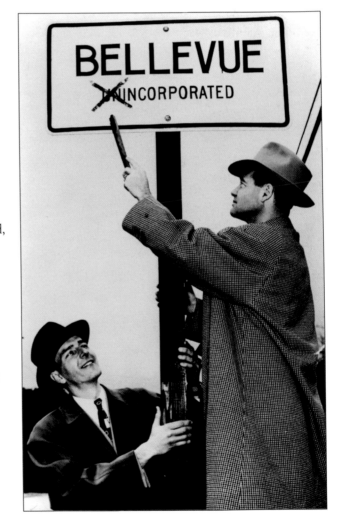

INCORPORATION. Shortly after Bellevue residents voted to incorporate in March 1953, Eugene Boyd and Phil Reilly posed for this photograph celebrating Bellevue's self-governance. Until then, all the land between Houghton and Renton had been unincorporated, with decisions about important services left to the three-member county commission. As an unincorporated area, Bellevue had to compete with other fast-growing suburban areas for the attention and funding of the county, which was always inadequate. In order to get moving on road and sewer improvements, obtain adequate police and fire protection, and, most importantly, gain control of planning and zoning, Bellevue would need its own municipal government. The original boundaries of Bellevue covered an area of roughly five square miles.

NEW CITY LEADERSHIP. Bellevue incorporated under the council-manager form of government, which was popular at the time. Under this form, which is still in place, seven councilmembers are elected at-large in the city, and after each election, the council chooses one member to serve as mayor for a two-year term. The council, in turn, hires a city manager who runs the operations of city government. The photograph at left shows Bellevue's first mayor, Charles Bovee, who had founded Bellevue Realty in 1925. Below is Evan Peterson, Bellevue's first city manager. (Both, courtesy of the Washington State Archives.)

CITY STAFF. When smaller cities incorporated in the 1950s, many took advantage of the newly popular practice of contracting with other governments for city services. Bellevue, however, chose to build its own city government. It began with a police department and public works staff, and gradually took over from existing utility and fire districts. Bellevue, in turn, became the fire and utility service provider for smaller, adjacent cities. Shown above is the city engineering department in 1955; below are city employees at a staff picnic in Meydenbauer Park in the early 1960s. (Above, from the collection of Eastside Heritage Center; below, courtesy of the Washington State Archives.)

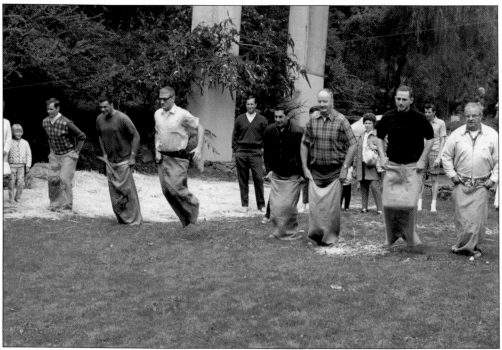

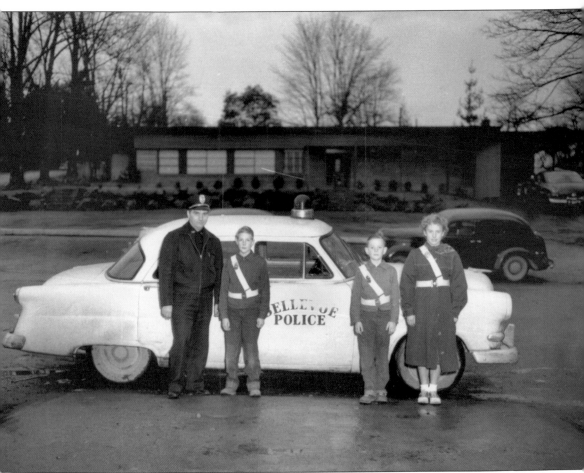

BELLEVUE POLICE. Of all the local services that county government provided to unincorporated areas, police service was perhaps the most inadequate. The county sheriff could not provide much coverage, and with population and business growing, Bellevue needed its own police department. The new city council created one within weeks of taking office. Shown here is officer John Oprey with Bellevue's first police cruiser and some junior assistants from school crossings. This photograph was taken in front of Bellevue's original city hall on Main Street. (Courtesy of Bellevue Police Department.)

GREETINGS FROM THE BELLEVUE POLICE DEPARTMENT. While it was certainly serious about public safety, the Bellevue Police Department did have a sense of humor, as illustrated by its annual Christmas cards showing department personnel. (Courtesy of Bellevue Police Department.)

LONGTIME CHIEF DON VAN BLARICOM. Don Van Blaricom served in the Bellevue Police Department from 1956 to 1985, becoming chief in 1975. He worked to modernize the department and meet the needs of the growing city. Bellevue was one of the first cities in Washington to offer training on handling domestic-abuse cases and was the first department in the state to add blue lights to its police cars. (Courtesy of Bellevue Police Department.)

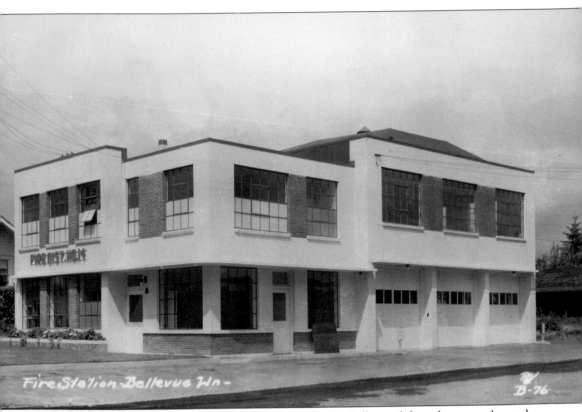

BELLEVUE FIRE STATION. As a rural, unincorporated area, Bellevue did not have to rely on the county for fire service but created its own volunteer fire department (which became Fire District No. 14) in the 1920s. The Bellevue fire station, at the corner of 102nd Avenue and Northeast First Street, was built in 1945 and still stands.

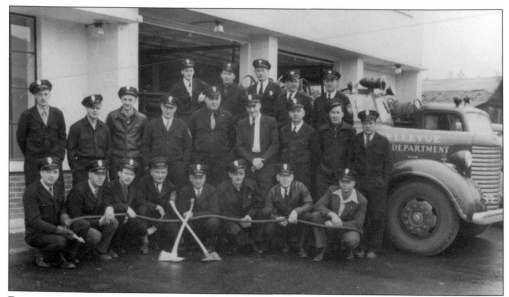

BELLEVUE VOLUNTEER FIREFIGHTERS. As new cities incorporated in the 1950s, they inherited a patchwork of special-purpose districts that provided water, sewer, and fire service. Because these districts generally provided adequate service and operated beyond the boundaries of the new city, Bellevue did not absorb them for a number of years. Bellevue Fire District 14, with volunteer firefighters shown here at the Bellevue fire station, remained in place until Bellevue created its own fire department in 1965. Four years later, the Bellevue Fire Department took over the fire district that covered the Points Communities, and it has contracted with those cities for fire service ever since.

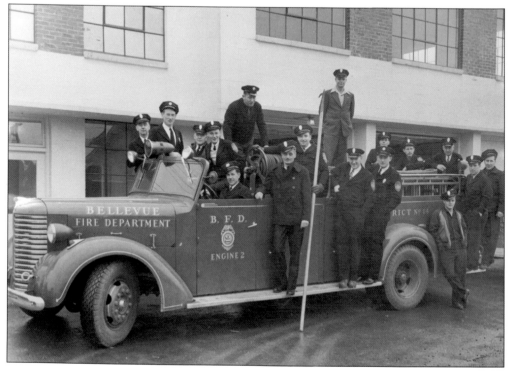

ORIGINAL BELLEVUE CITY HALL. After incorporation, the new city needed a new home. It found one in a very appropriate place, the Veterans of Foreign Wars hall at the corner of Main Street and 100th Avenue. The VFW hall had been built in 1893 as Bellevue's first permanent schoolhouse and would now return to public service. The building served as city hall until staff moved to a larger (but still temporary) home a few blocks away.

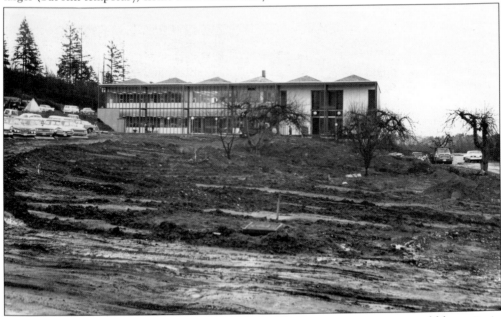

NEW LOCATION FOR CITY GOVERNMENT. The next stop for city government would be a site in the wilderness, at the corner of Main Street and 116th Avenue. The city hall would be on the other side of the new Interstate 405 corridor, in an area that had been settled since the 1880s, but remained rural. (Courtesy of the Washington State Archives.)

DEDICATING THE NEW CITY HALL. On March 7, 1964, eleven years after incorporation, Bellevue got its first permanent city hall. Shortly after, a new public library would be built on the adjacent property. As Bellevue grew from a population of 14,000 people in 1964 to become one of the largest cities in the state, it would outgrow this city hall. The 1964 building would be replaced with a new structure on the site in 1978. Then, in 2007, city hall moved back downtown to its current site. (Above, courtesy of the Washington State Archives; below, from the collection of Eastside Heritage Center.)

FRED HERMAN. The first act of the new city after incorporation was to create a planning commission. And one of the commission's first acts was to hire Fred Herman to serve as planning officer. The 1950s was a golden age of planning, with both industry and government confident of their ability to create the future they wanted through rigorous analysis of data and imaginative urban design. No other suburb in the region was able to get out as far ahead of growth as Bellevue, which saw the rapid development along its periphery and made sure it remained the most important commercial center of the Eastside. Bellevue's intentionality shone through in its aggressive approach to planning, headed up by Herman, who served the city until 1975. Herman is shown here discussing Bellevue's future with a citizen who would see how his department's plans panned out.

ROADS TO NOWHERE. One of the most difficult things for a local government to do is to create surplus infrastructure capacity to meet future needs. Bellevue, in its early days, anticipated and planned for the growth it could see coming and built its road network well ahead of the development of its large commercial center. Roads, like this one, that seem to serve nothing are now part of Bellevue's core. (Courtesy of the Washington State Archives.)

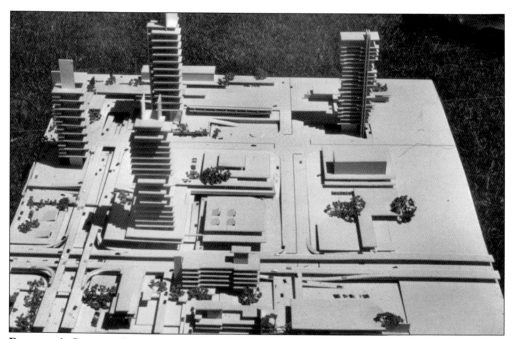

BELLEVUE'S CENTRAL BUSINESS DISTRICT URBAN DESIGN CONCEPT. When James Ditty published his plan for Bellevue that included skyscrapers, everyone laughed. By the 1960s, however, plans were being considered for Bellevue that made Ditty City look almost modest. And looking at Bellevue today, even these plans seem modest. What is important is that the groundwork laid in the 1950s and modernized in the 1970s and 1980s, allowed for the compact, tall, vibrant downtown that Bellevue has today.

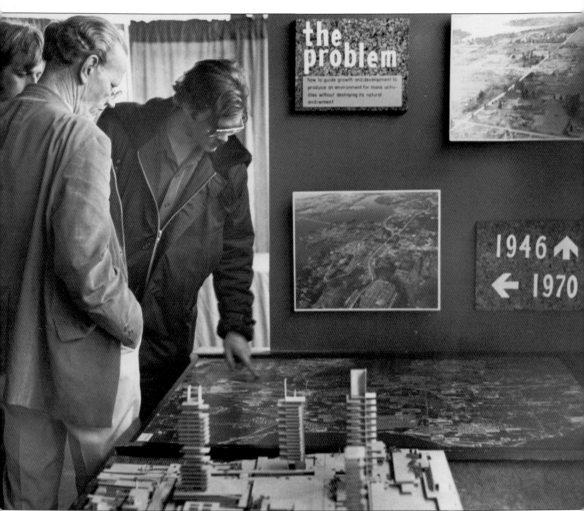

PLANNING BELLEVUE'S NEXT PHASE OF GROWTH. In 1970, Bellevue undertook a planning process that, from the look of the models in this photograph, envisioned a major urban center. "The problem," as stated on the wall, sums up the challenge Bellevue has faced—and largely met—from its beginnings in 1953: "How to guide growth and development to produce an environment for man's activities without destroying its natural endowment."

Nine

GROWING UP

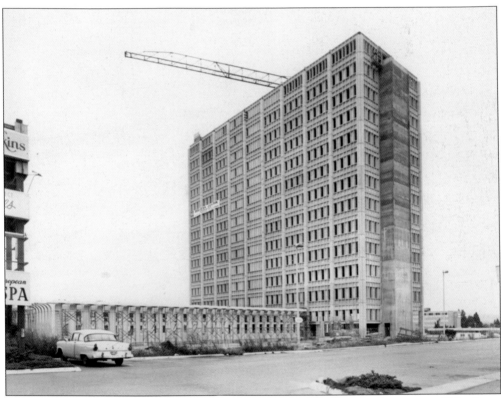

SKYSCRAPERS COME TO BELLEVUE. The Business Center Building, at the corner of Northeast Eighth Street and 106th Avenue, opened in 1969, the close of the period covered in this book, and symbolizes the start of a new era for Bellevue. In the 1950s and 1960s, Bellevue and its surrounding areas grew rapidly, adding large residential populations at the beginning and gradually developing the public services, retail, and other amenities that would give locals fewer reasons to go to Seattle. This development, aided by aggressive infrastructure programs, laid the groundwork for the next era, in which Bellevue would become a much more significant employment center. By the turn of the century, Bellevue had more jobs than residents, officially shedding its old image as a bedroom community.

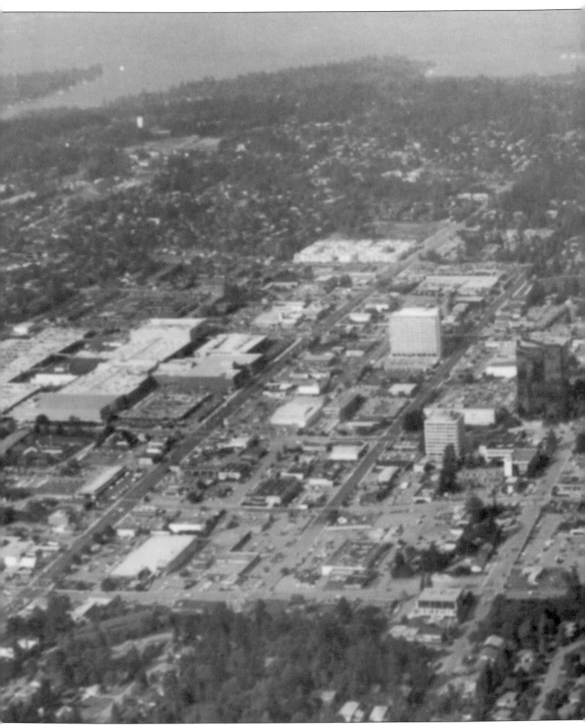

DOWNTOWN BELLEVUE IN THE 1980s. This photograph shows downtown Bellevue in the midst of a major commercial building boom during the 1980s. Bellevue Square had completed its transformation to an enclosed mall, and 30-story buildings had begun to emerge on 108th Avenue. The process of filling in the pastures, begun in the 1950s, was complete, and downtown

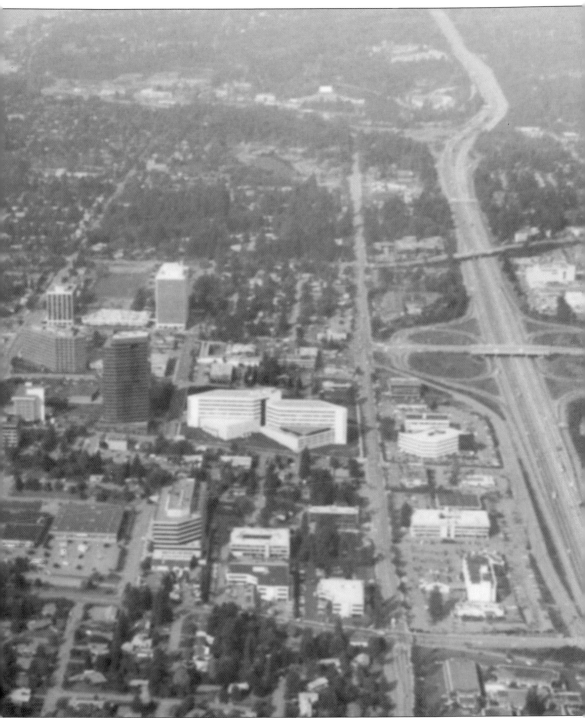

Bellevue was fully built-out. By 1980, Bellevue itself had a population of about 75,000, making it the fourth-largest city in the state. Meanwhile, the core of the Eastside was approaching 130,000 people. Downtown Bellevue had become the primary commercial center for the entire Eastside and was poised to grow even more.

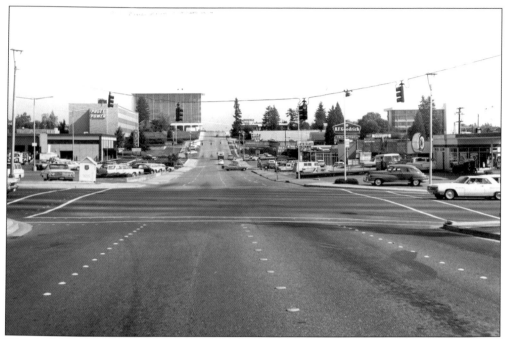

WIDE STREETS FOR FUTURE GROWTH. When Bellevue incorporated in 1953, planners inherited a rudimentary street grid that mostly served vacant land. The automobile was king at the time, and the city decided to create a system of superblocks, with roads that would be spaced farther apart but have very large capacity. The photograph above shows Northeast Fourth Street climbing up to Bellevue's first skyscraper, which was completed in 1968. The photograph below shows 106th Avenue a few years later. (Above, courtesy of the Washington State Archives; below, from the collection of Eastside Heritage Center.)

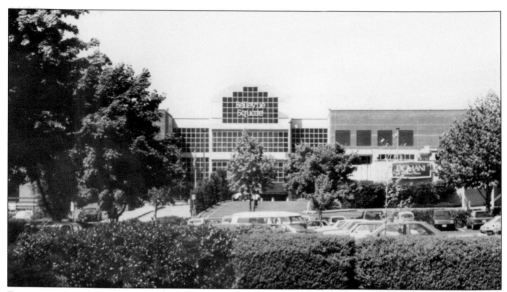

BELLEVUE SQUARE GOES INDOORS. The original Bellevue Square shopping center, modeled on a center in Texas, was oriented around the automobile, with an emphasis on easy parking and access to stores. But it was only a matter of time before the Eastside acquired a much larger regional mall, such as Southcenter, which had opened in 1969. After helping battle plans for the proposed Evergreen East shopping center on what is now the Microsoft campus in Redmond, the Freeman family broke ground in 1980 on what would become the Puget Sound region's premier shopping mall.

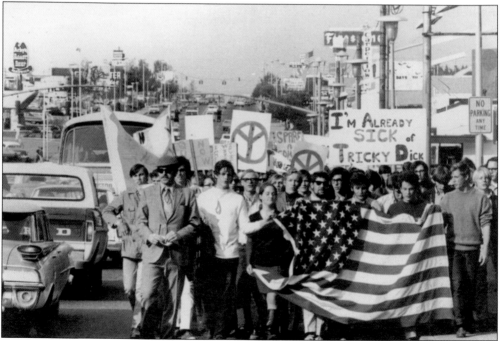

PEACE MARCH IN BELLEVUE. By the late 1960s, national and world events had come to Bellevue. In this march through downtown Bellevue, which took place in January 1969, protestors took issue with the inauguration of Richard Nixon. (Courtesy of the Bellevue Police Department.)

THE OLD PASSES AWAY. One by one, the old buildings of Bellevue were replaced, and most of these structures were unlamented. One building did, however, cause some tears to be shed: the Union S High School that stood on the site of the Bellevue Downtown Park. Opened in 1930, the three-story school was the largest building in Bellevue and symbolized the community's commitment to grow into a more substantial place. The new park, in turn, symbolized Bellevue's commitment to match that growth with a high quality of life.

BELLEVUE IS STILL ABOUT BUSINESS. Bellevue grew up around a vital business community, and the leadership of business in shaping the city has never wavered. In spite of some major disagreements among business leaders over the years, there has never been any question about their commitment to Bellevue's well-being. In this photograph from a Bellevue Chamber of Commerce annual dinner are, from left to right, Dan Wick, Roger Fosseen, Bob Wallace, and Joan Wallace.

THE CRYSTAL BALL. Divining the future is not easy, and it appears that Fred Herman (second from the left) and his colleagues tried all sorts of methods. But perhaps they did not need to see the future to prepare for it. Vision is not about knowing what is to come—no one can do that—but about laying the groundwork that will allow a community to take advantage of opportunities that present themselves. A new bridge across Lake Washington, combined with a lot of vacant land and a rapidly growing metropolitan area, meant opportunity for Bellevue to grow into a major residential and commercial center. City officials of the 1950s could never have envisioned what Bellevue would develop into, but the plans they drew up and the actions they took suggest that they knew the city would become something big. (Courtesy of the Washington State Archives.)

Discover Thousands of Local History Books
Featuring Millions of Vintage Images

Arcadia Publishing, the leading local history publisher in the United States, is committed to making history accessible and meaningful through publishing books that celebrate and preserve the heritage of America's people and places.

Find more books like this at
www.arcadiapublishing.com

Search for your hometown history, your old stomping grounds, and even your favorite sports team.

Consistent with our mission to preserve history on a local level, this book was printed in South Carolina on American-made paper and manufactured entirely in the United States. Products carrying the accredited Forest Stewardship Council (FSC) label are printed on 100 percent FSC-certified paper.

MADE IN THE

USA